COLOR Me CHiLLeD OuT

coloring pages for meditation & relaxation

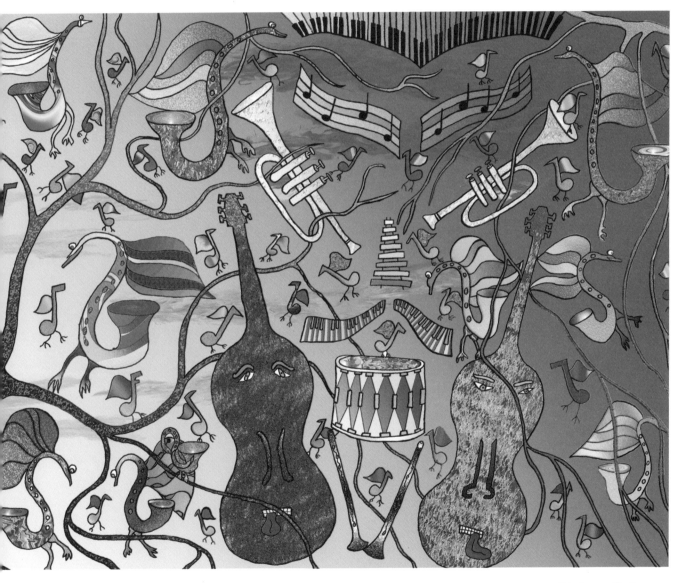

Robert Schrag

NORTH LIGHT BOOKS
CINCINNATI, OHIO
www.artistsnetwork.com

Contents

▶ **The Musician**
See *People* for this and related coloring pages.

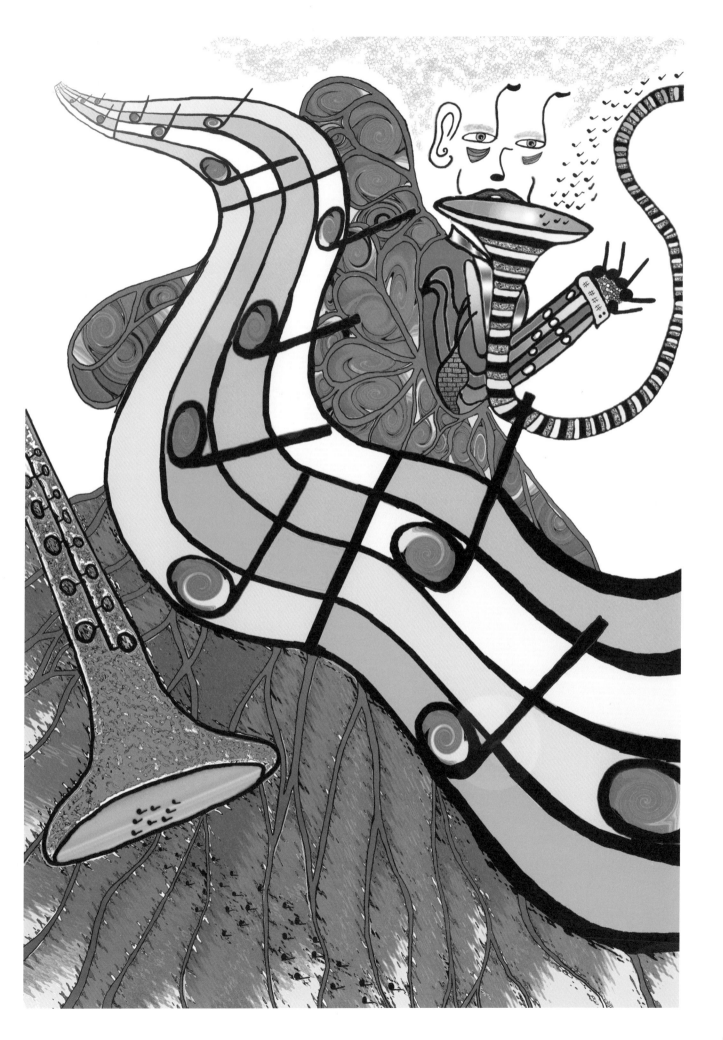

Congratulations!

By opening this book you are taking a positive step in claiming a bit of precious time and some peace of mind for yourself. That is something we rarely do in the hyperactive, hurly-burly, multitasking digital world that is the twenty-first century. Mind you, I have nothing against technology. I have taught about it for more than thirty-five years. I use it everyday. It has played an important role in creating the images in the following pages. But I have learned something else in the full span of my sixty-plus years, and that is that technology and the multitasking it encourages, can—in addition to all the wonderful things it does for us—create a life that is incredibly stressful. We need only look around us as we walk down the street. How many people are texting away? In their cars!? Talking, seemingly into the air, until we see the ear-piece linking them to their cellphone. Do you and your friends put your phones on the table when you have lunch together? Do your or your friends have trouble tearing your eyes away from one screen or another?

It seems that we spend most of our lives clicking from one task to another, spreading ourselves thin, breaking ourselves up into little pieces. This book is all about reversing that pattern. It is about focusing on one pleasant task, about diving deeply into one calm space, it is about putting ourselves back together again. It is about coloring as a healing, meditative activity.

There are probably as many definitions of meditation as there are books in the self help or spirituality sections of your favorite bookstore. Having grown up in the 1960s, I have heard most of them. And while each may have its own special twist or emphasis, they all eventually hope to lead us to the same place—a calm and tranquil place, a place where we can find peace of mind.

Another common element in most meditative practices is to use some type of repetitive pattern to shut out external distractions and allow us to focus on the reservoir of calm that lies within us all. It can be breathing, or movement, or music, or whatever. For us, in this book, it is the calm application of color to spaces. No worrying about the right color. No rush; just the quiet movement of pen or marker or pencil or pastel on the paper. The only multitask I use with meditative coloring is sound—music, usually without lyrics, or nature sounds, perhaps blended with music. The object is not to foreground the sound, but rather to create a barrier to the outside world that allows us to focus on the quiet, calm application of color to paper.

As you allow yourself time to completely immerse yourself in meditative coloring—holding the distractions of invasive technologies at bay—you will discover that this gentle practice unlocks creativity in other areas. You may find yourself humming a tune as you wander the route to work and realize that it is one you made up yourself. Or, as you observe the world around you, you may find yourself describing it in words that, with just a little punctuation, could easily become a poem. Throughout the book I will share bits of text along with the drawings. These are examples of those little creative insights that popped into my head, sometimes while drawing, and sometimes while just resting in that calm space to which meditative coloring takes me.

So, when you are ready, turn the page and begin.

Cheers,
RL Schrag

▶ **Sei He Ki/Enable Beauty**
See *Distilled Harmony* for this and related coloring pages.

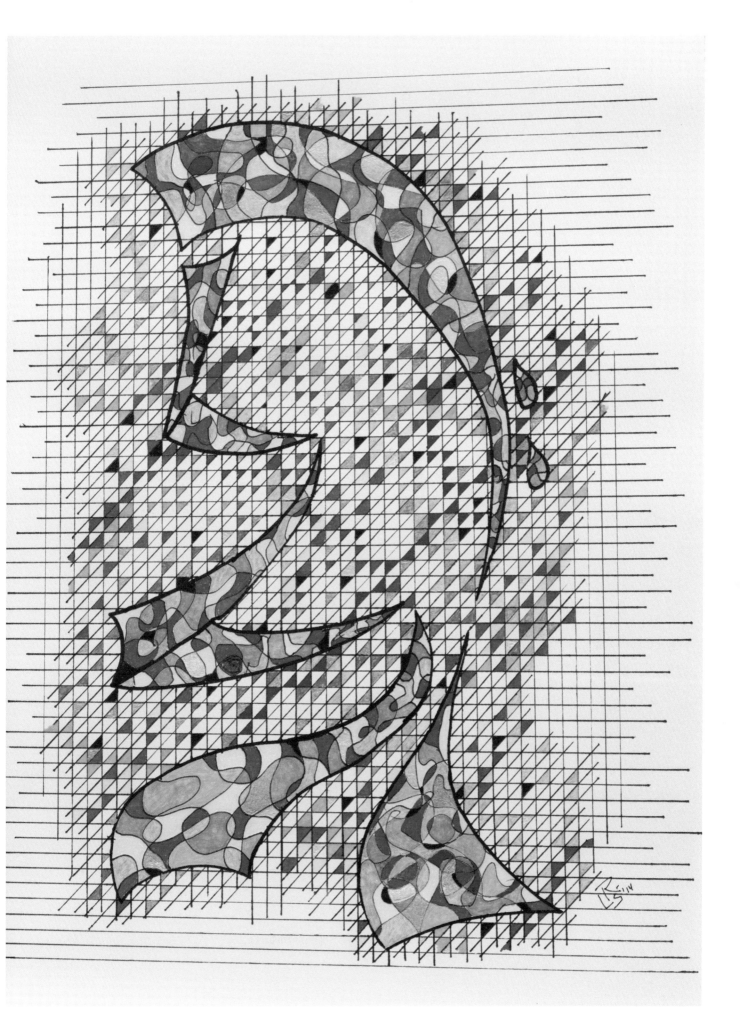

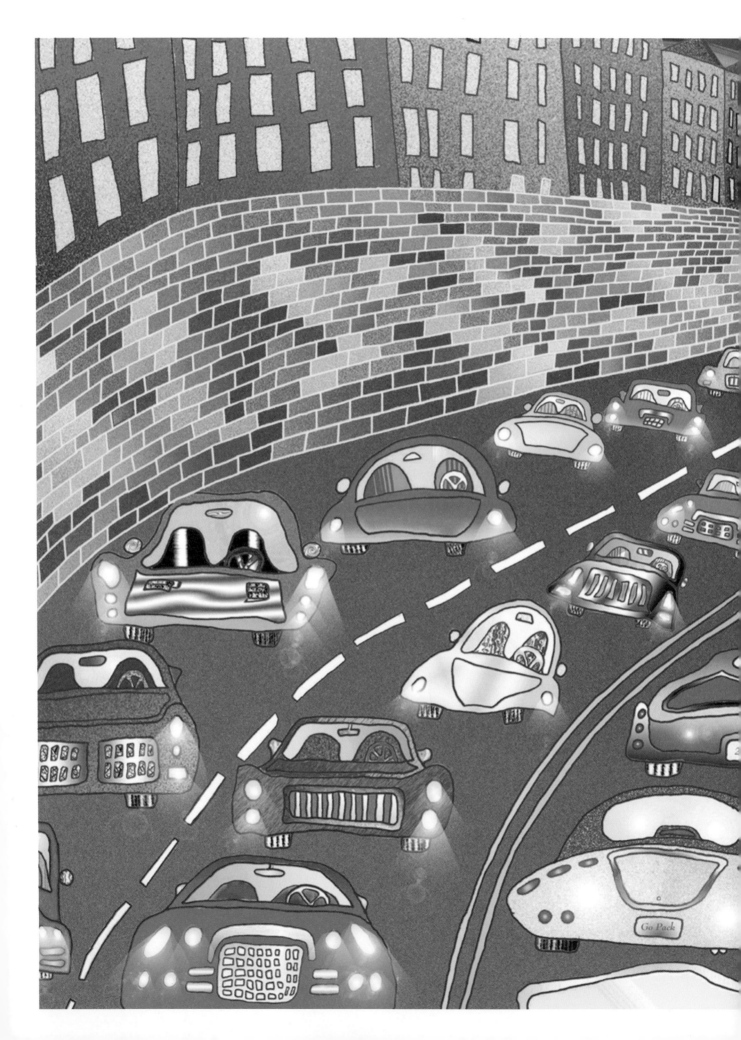

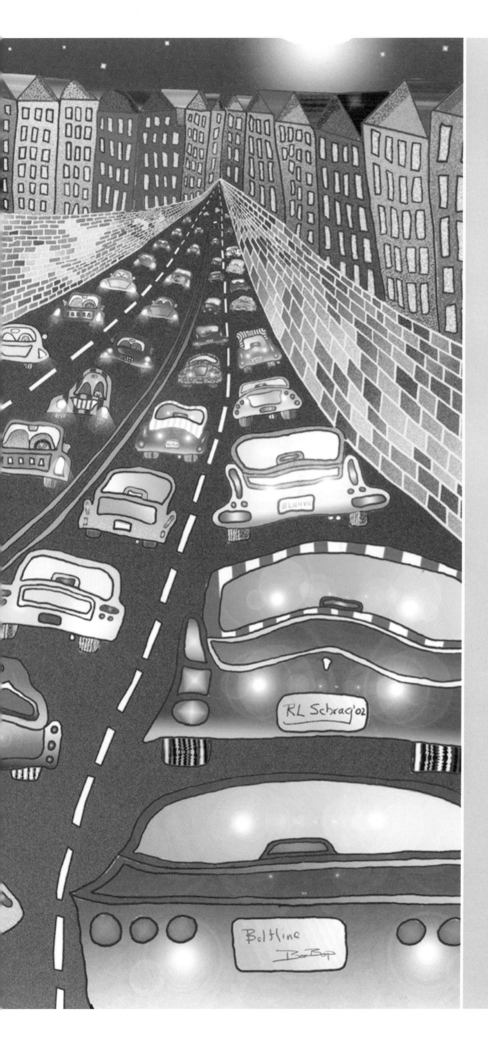

PLACES

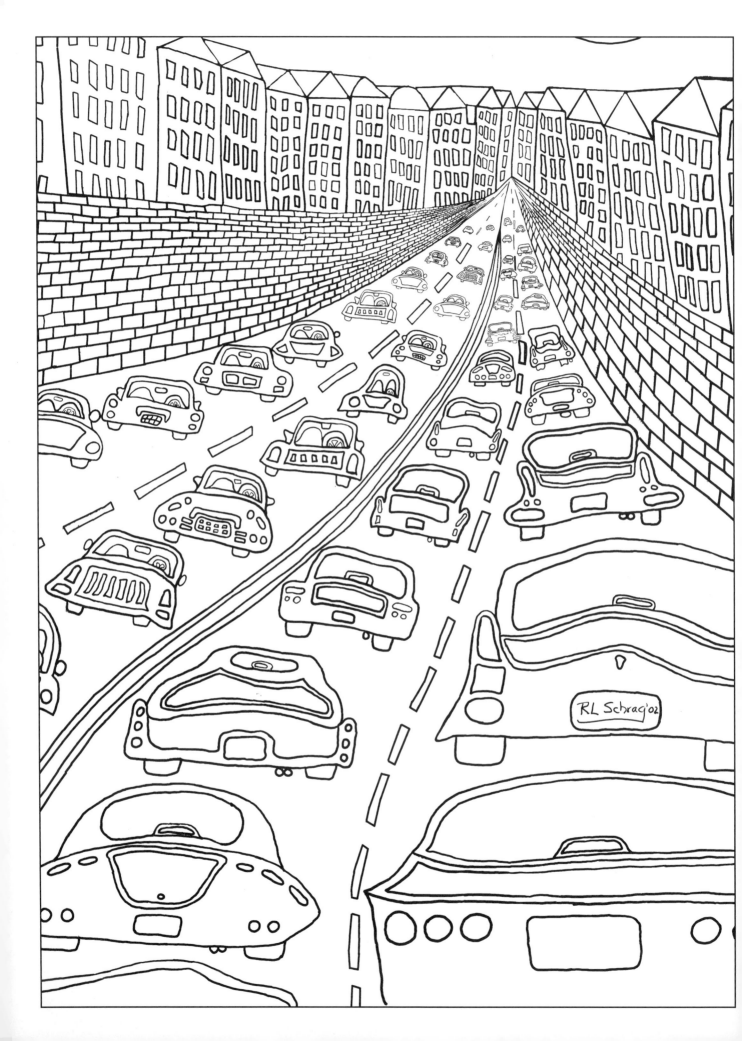

We aren't just looking for any old calm space. We want to go to "our" calm space, one that supports our view of the world. It is a back and forth kind of activity. We bring our worldview into the coloring and the coloring seems to center us in that view. It is a lifelong, gentle process. I have found that places have a way of showing up in my drawings. Rarely are they actual places. I don't try to draw Raleigh or Florence or Charleston. More often they are just windows and walls, buildings and what not. The only thing they have in common is the fact that I feel I would be happy there.

Beltline Boogie

We don't get much snow here in Raleigh, but we do get the occasional ice-storm that turns the entire city into a huge game of bumper cars. After one such event during which I was dinged three times on the way home, it occurred to me that the harmonic response was to see it as a dance. We all have bad traffic days, many caused by unavoidable inclement weather. Here's the thought: You can go nowhere until the vehicle in front of you moves. So just chill. Let them lead and follow when possible. And when you get home—stay there!

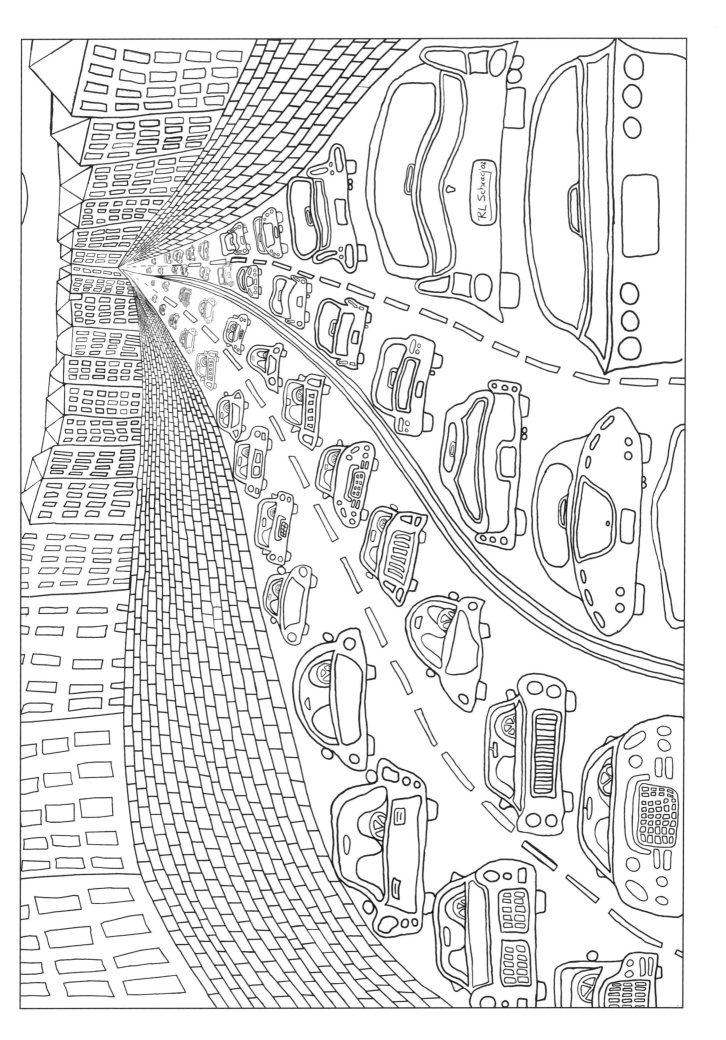

Arches

Arches always speak to me of what might be, or what has been.

Memory peeking out right next to possibility.

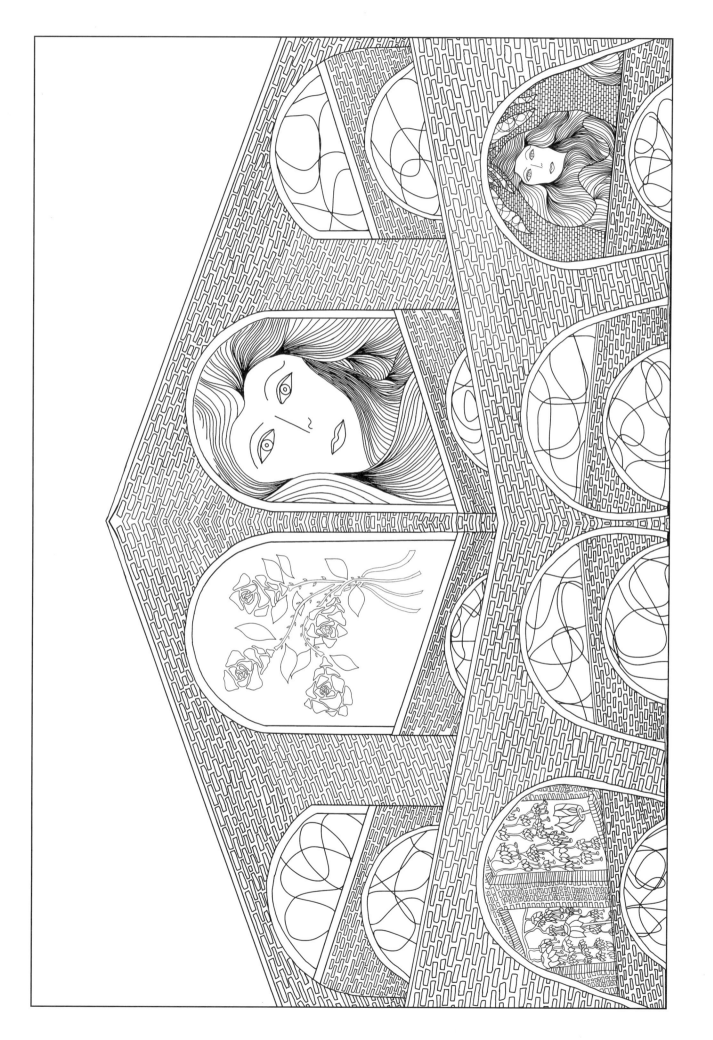

Landscapes

Windows in the rain? Maybe that is where these images spring from. The wash of the rain turns everything into an impressionist canvas, spaces just asking for color or shapes—as do these.

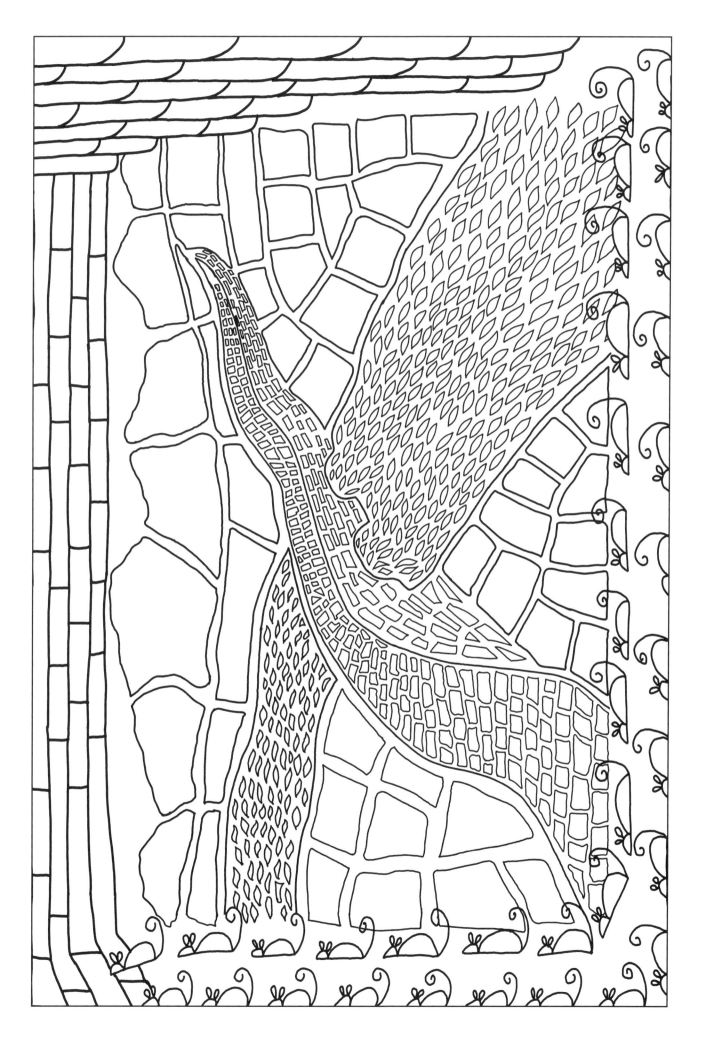

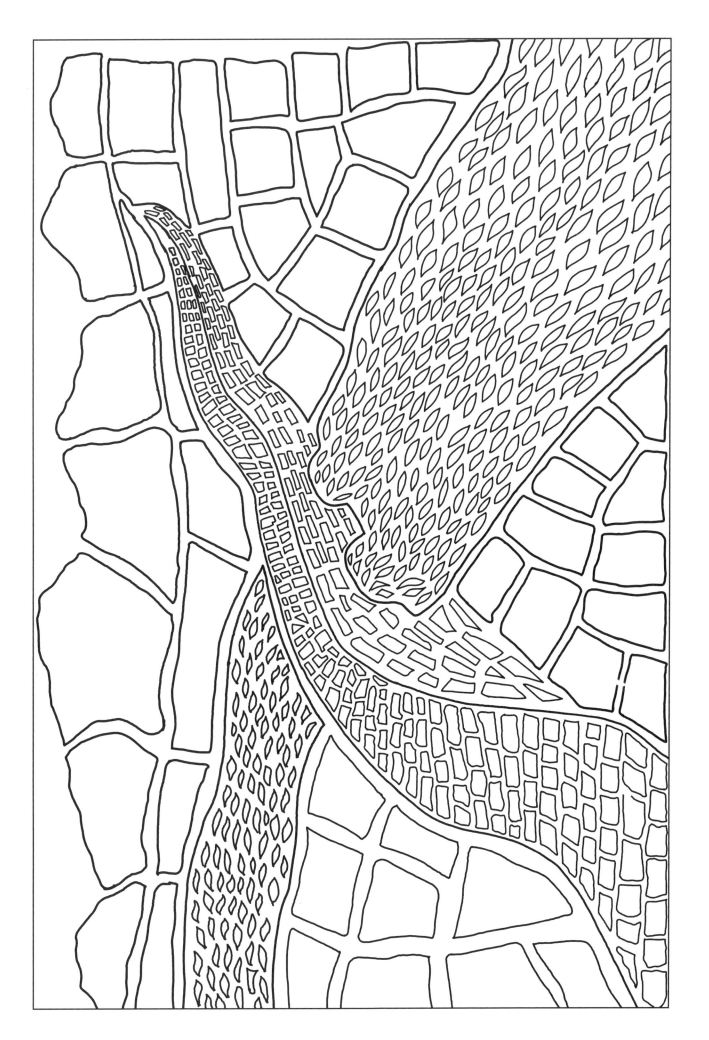

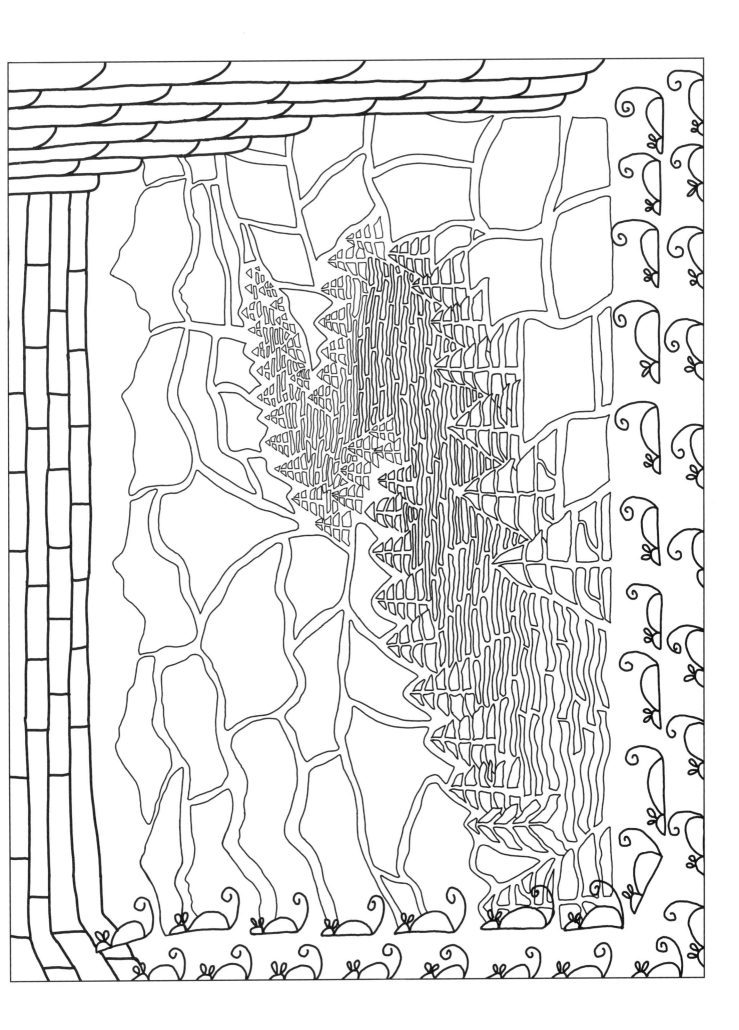

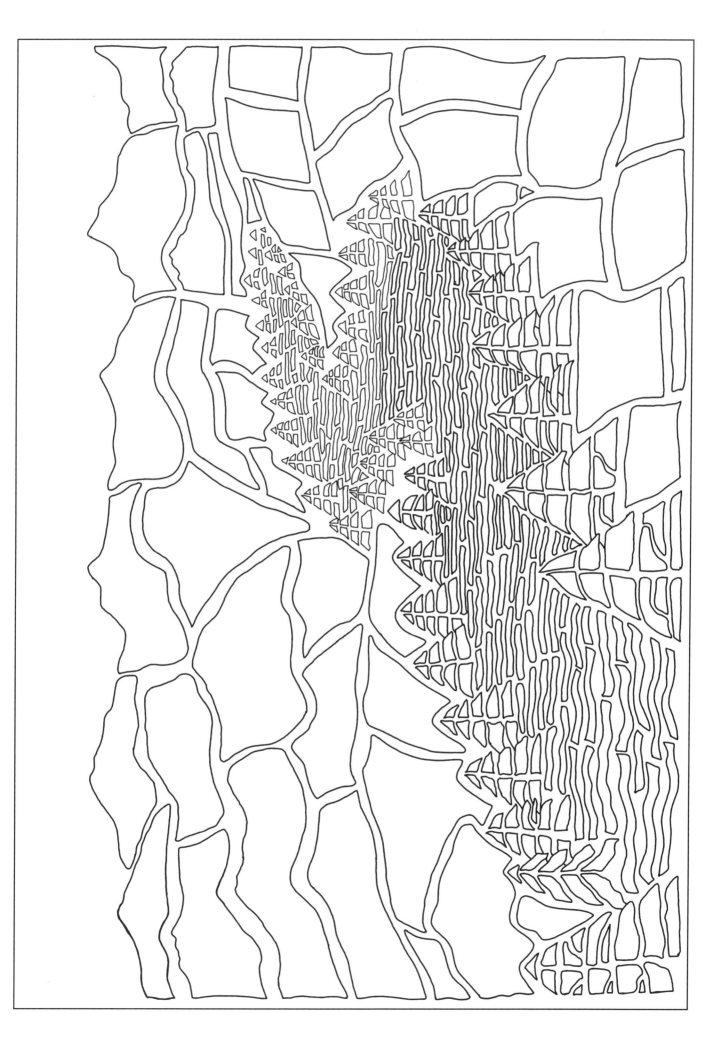

Flight of the Saxophones

When we go to the symphony my wife often accuses me of dozing. "Not so!" I protest. "I'm just watching the instruments in flight."

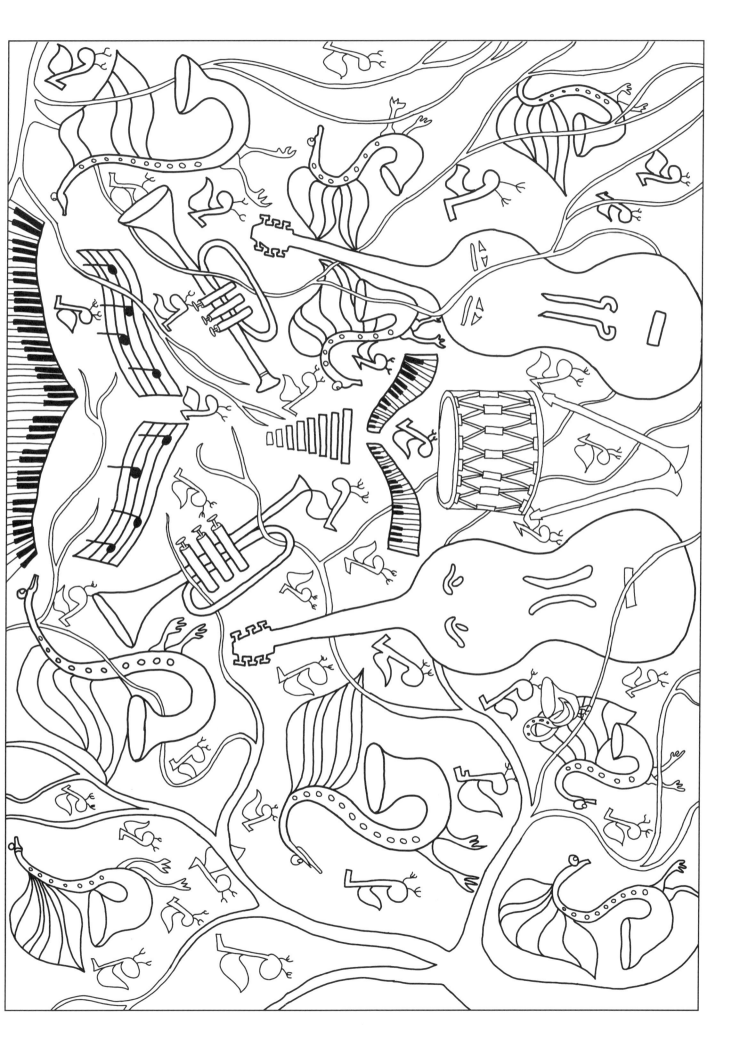

Keys

No, I never had this dream, and my computer tells me I drew the original before the Harry Potter film with the flying keys scene came out in 2001. But I suppose we all see life this way at some time or another—so many keys, but only one to fit the door.

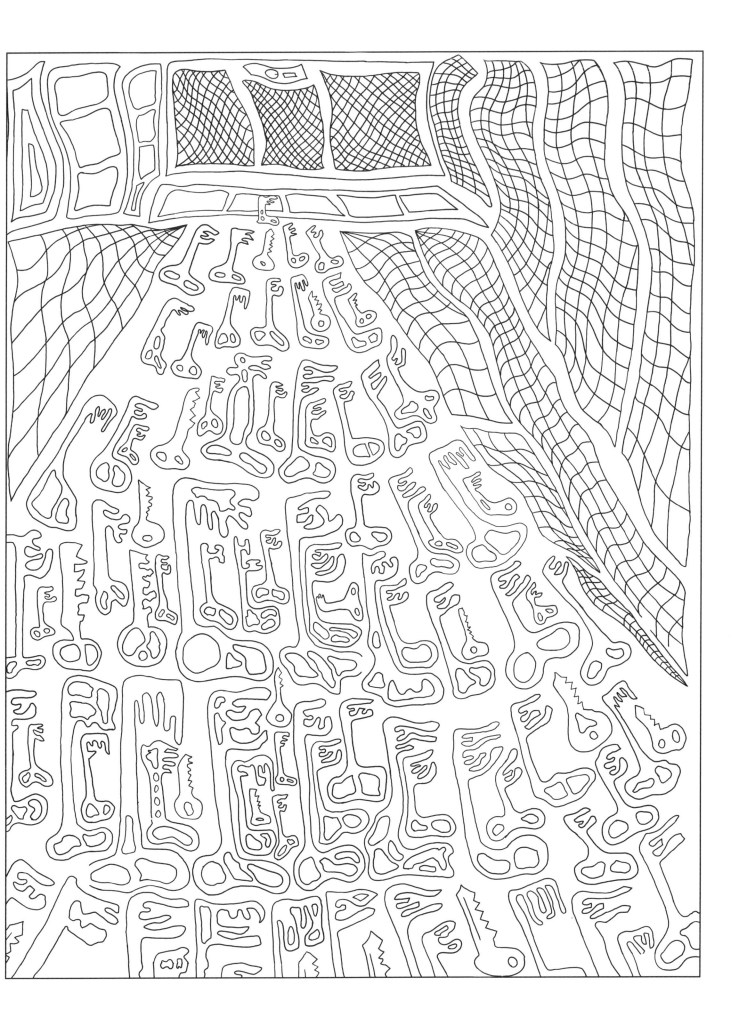

March of the Eggplants

I had originally intended to draw another story on the building, but then the eggplants came marching in, demanding to be heard.

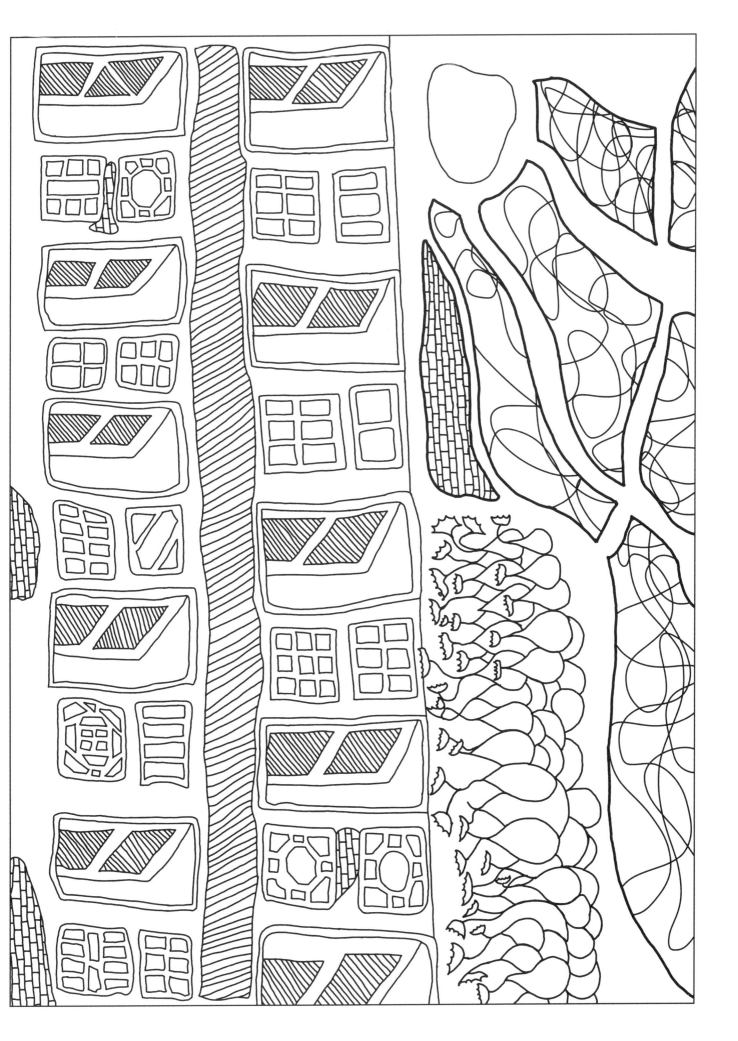

Smokestack

Out my office window, across the Court of North Carolina, on cold winter days, the steam would rise from the old laundry, swirling, falling and stealing away.

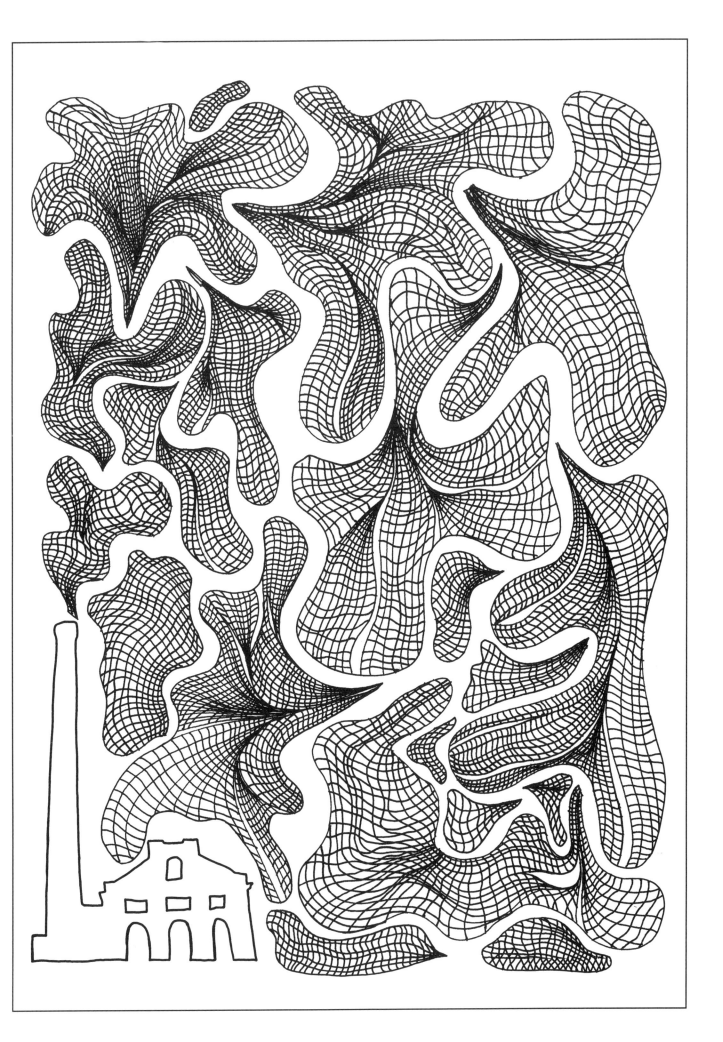

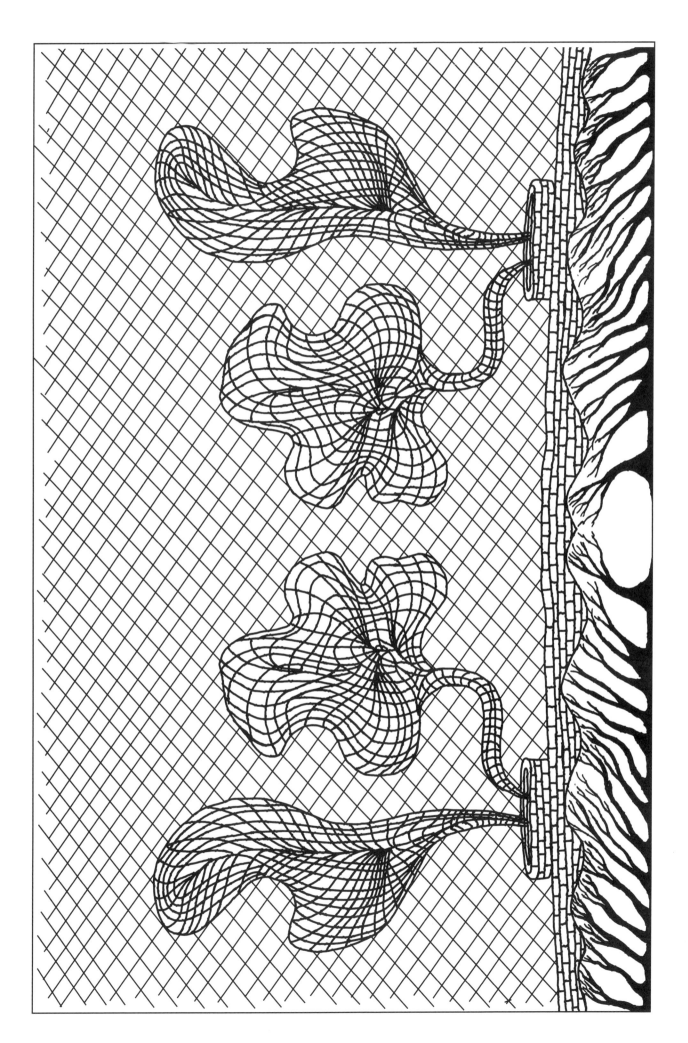

Through Every Window

No matter where the city, no matter what part of the globe, as we zip by on the Marta or Metro, we are entranced by the windows.

The Metro of the Mind

It is far past midnight.

Darkness surrounds the train.

Acceleration and rate are discernible

Only in the reflection of its own illumination

Racing bricks of tunnel walls.

A pneumatic whoosh of subtle decompression

Announces City Center; unfolding a

Silent film of momentary communion.

Across the tracks lie trains in silver skins

Streaked with blazing windows.

Within windows figures and faces

Mime insight and isolation, elation and despair.

Muted chimes announce the sigh of closing doors

As my several selves dissemble once again and

Go gliding down isolated tracks of purpose.

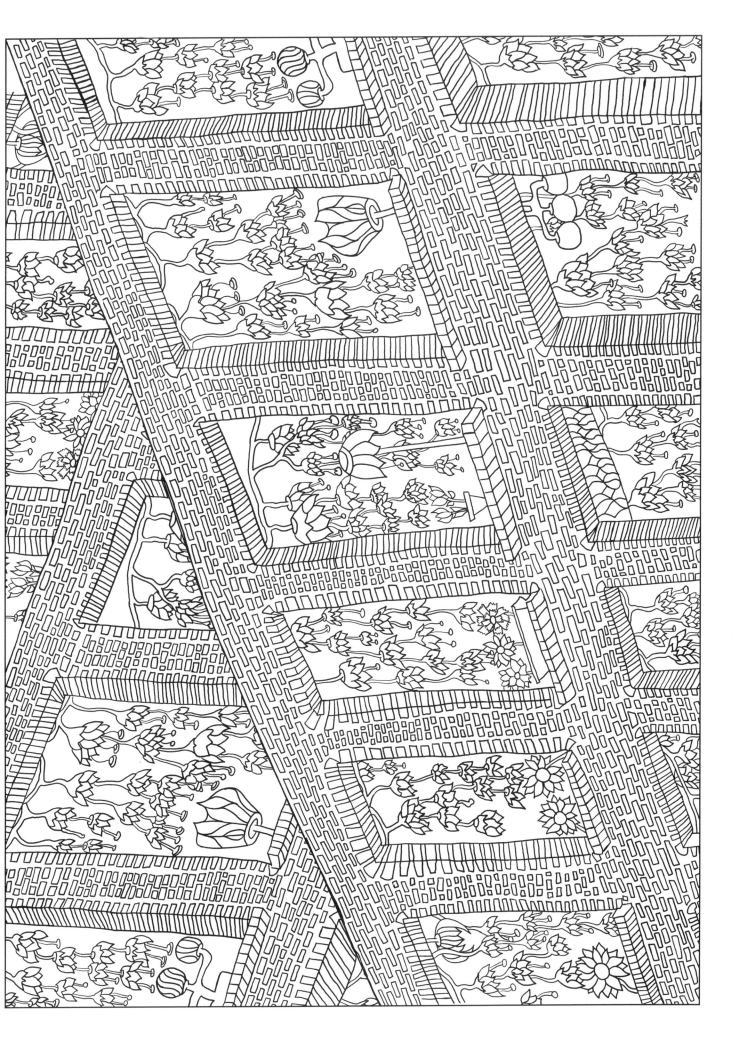

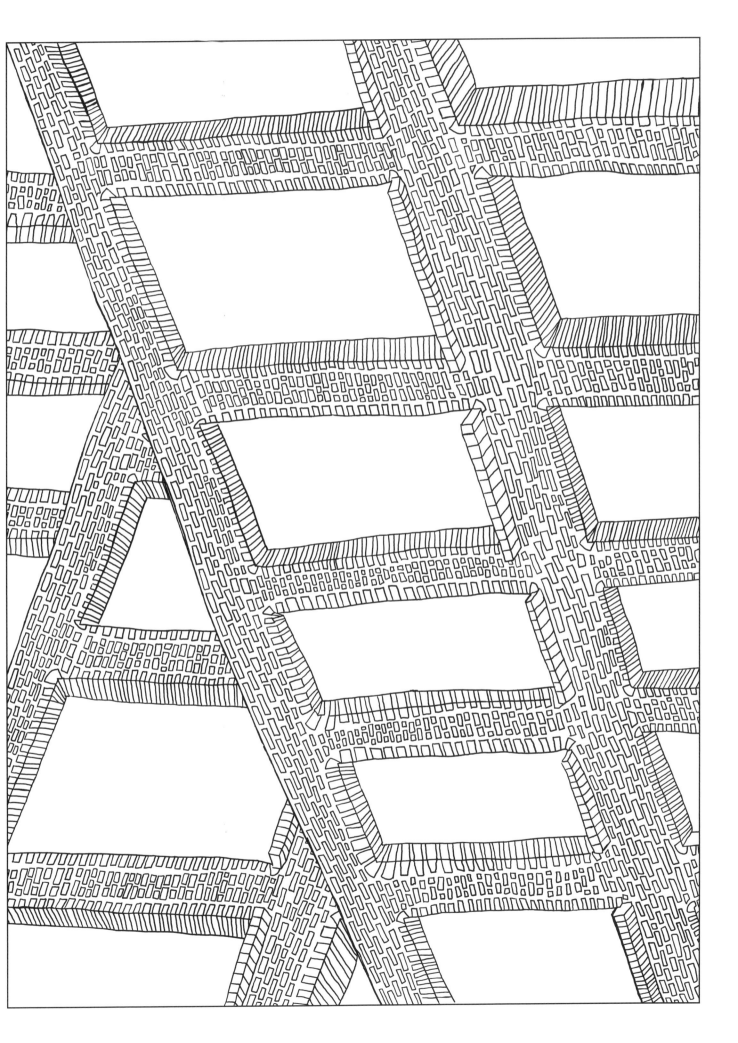

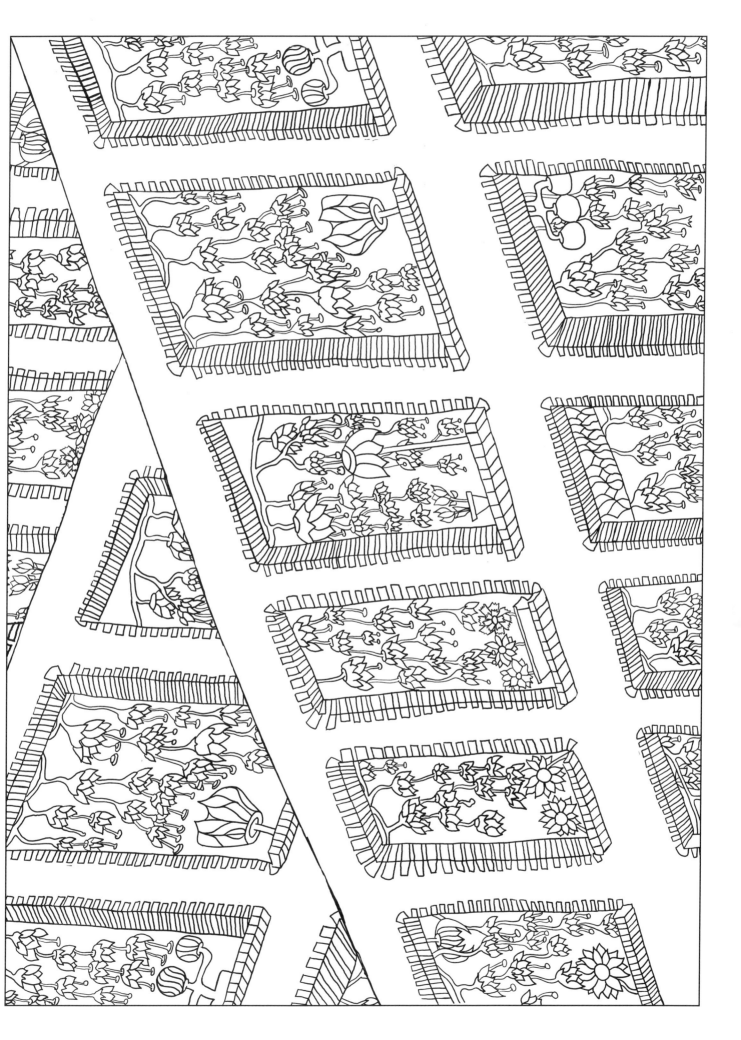

Winterscene

Brrrrrrrr. Humbug.

I hate the cold.

Ice glazes the world to immobility.

Sleeper's farce in tinfoil.

Pluto's infinite estrangement from the sun.

Cores from Greenland or Antarctica

Bear twisted slivers of warmer climes,

Battered fragments of happier times,

Petrified and crystallized.

It is not always a gradual evolution

From mill pond to skating rink,

All wreathed in abstract designs

Etched by the smoke of winter fires,

Entrusted to the mail—mantelpiece bound.

There are moments of instant transformation

Bringing an Ice Age of the soul

To freeze the beating of a lover's heart.

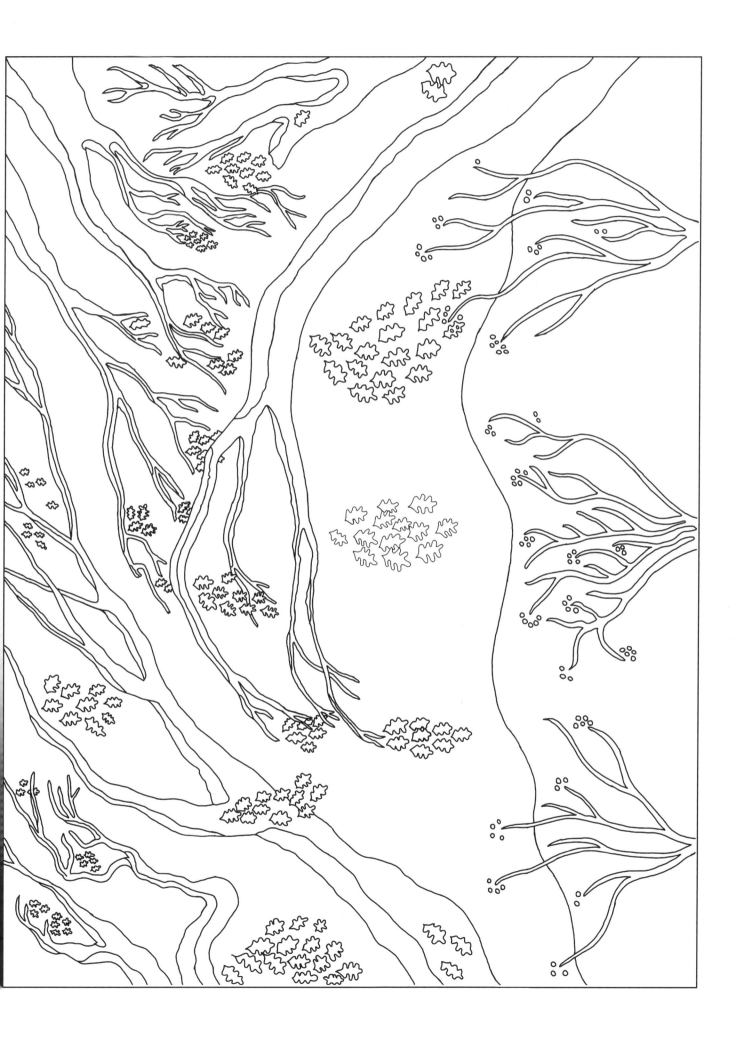

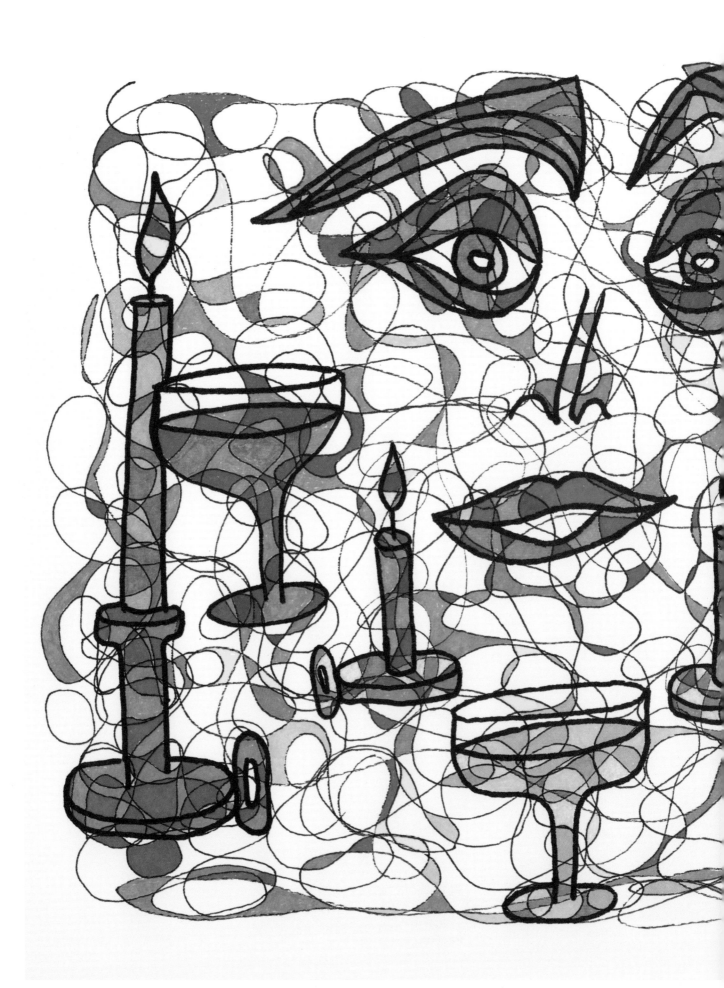

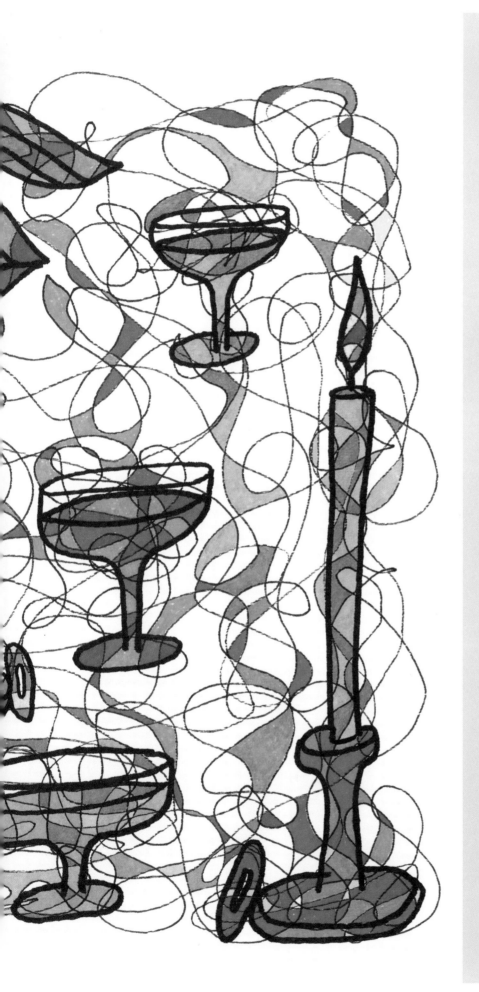

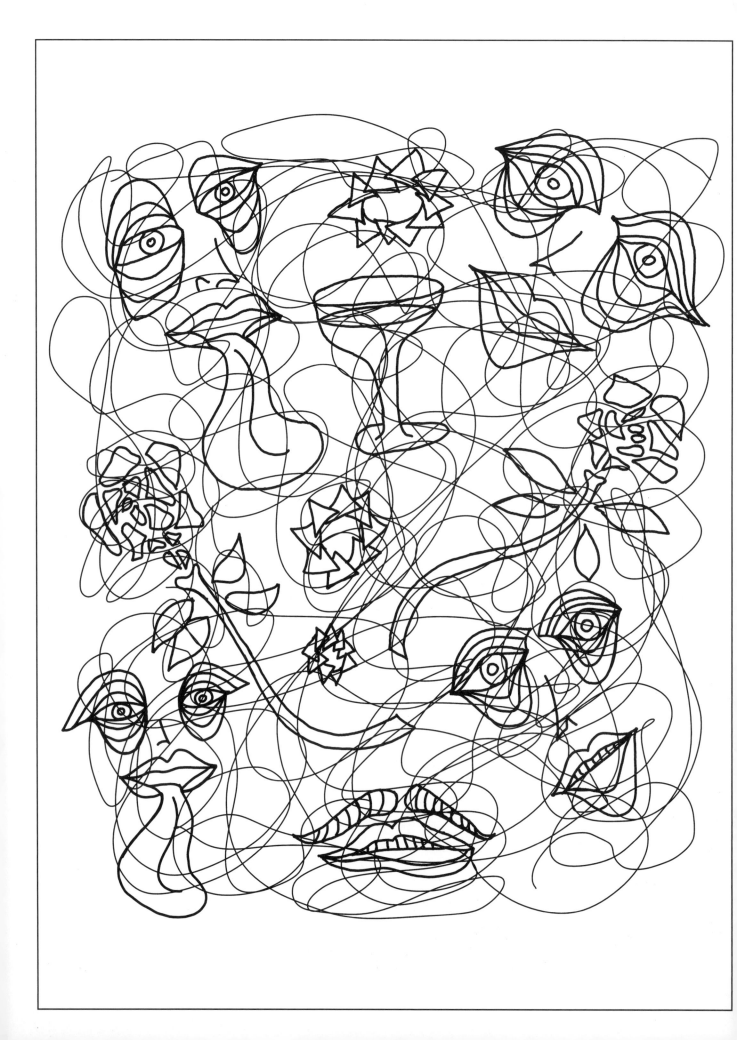

Window to the soul? Who knows, but eyes and faces hold a special magic for us. Babies recognize their parents at very early ages. Ancient drawings and masks hint at pasts that still peek out at the present. As an young theater major, I was always intrigued by the changes I could create as I put on my makeup, gradually becoming a stranger who somehow retained my eyes. No doubt these images spring from some of those roots.

Eyes

Unlike many of my drawings, I know from where this one sprang. We were in Venice—looking at masks!

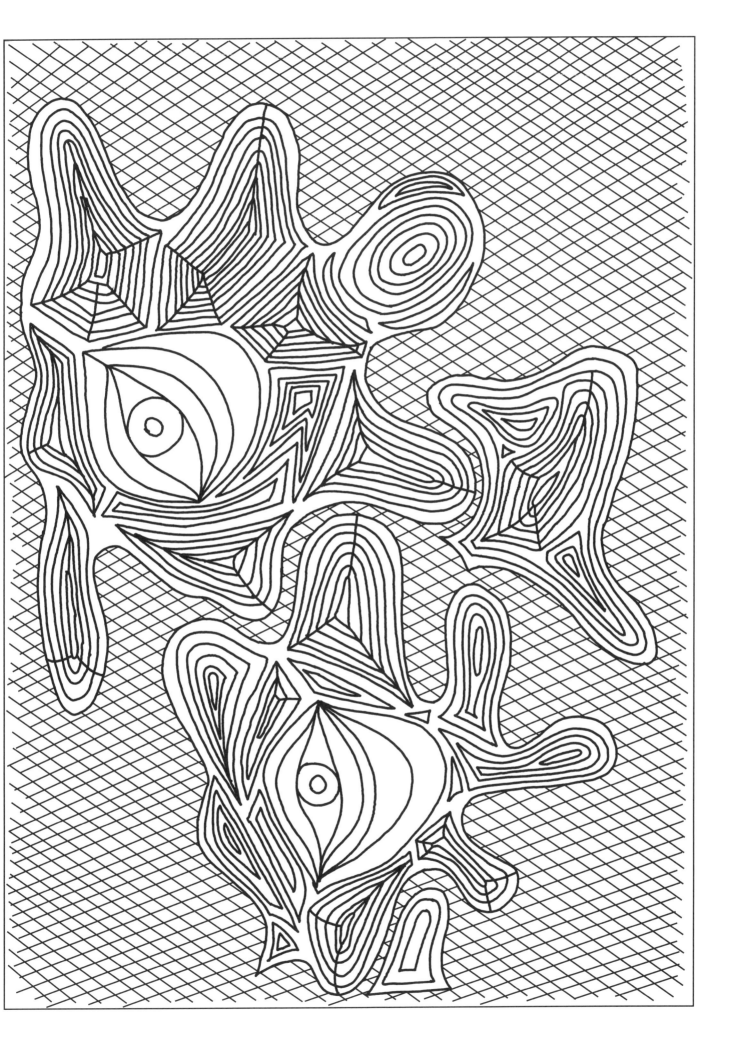

Faces and ...

Apparently I really loved those masks, and the wine, and the flowers and ...

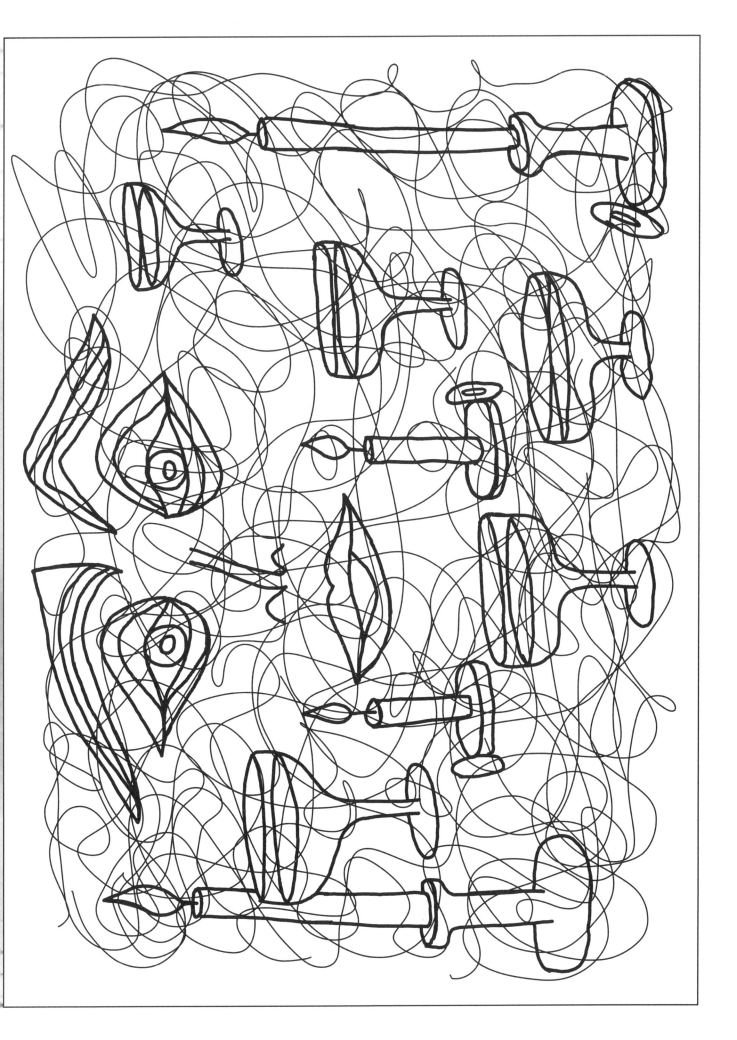

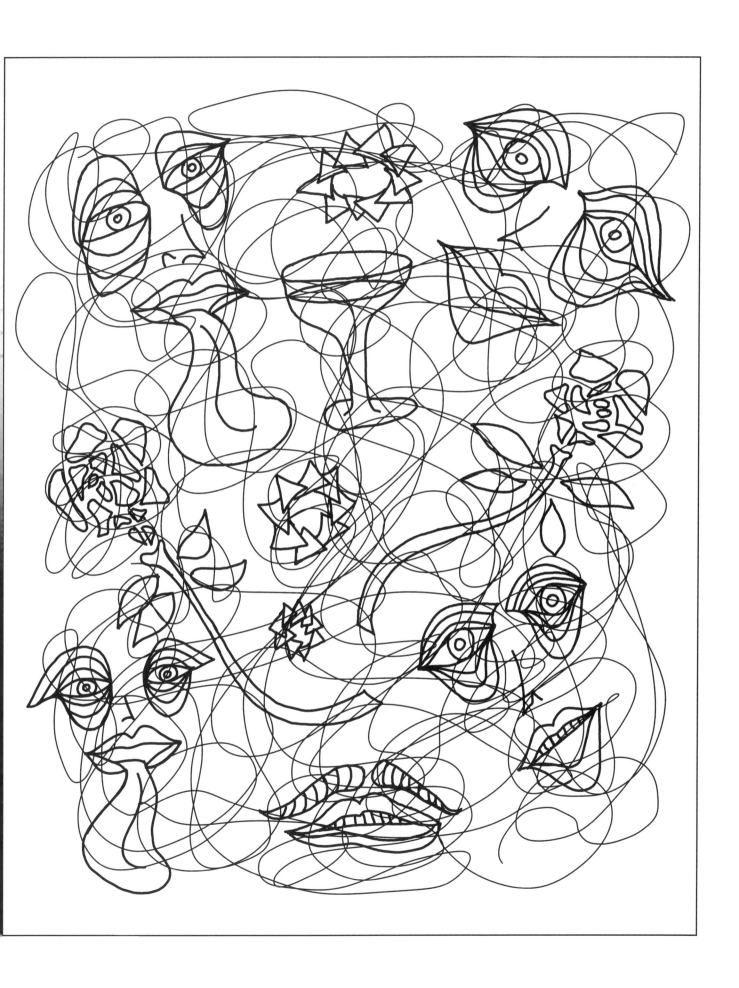

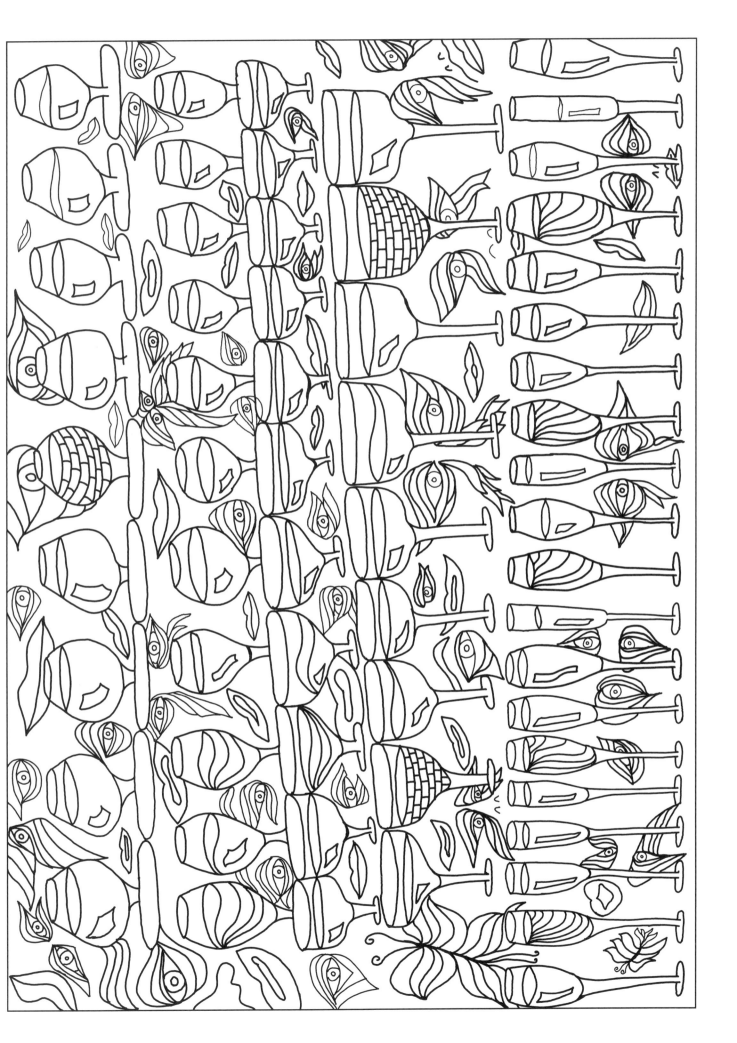

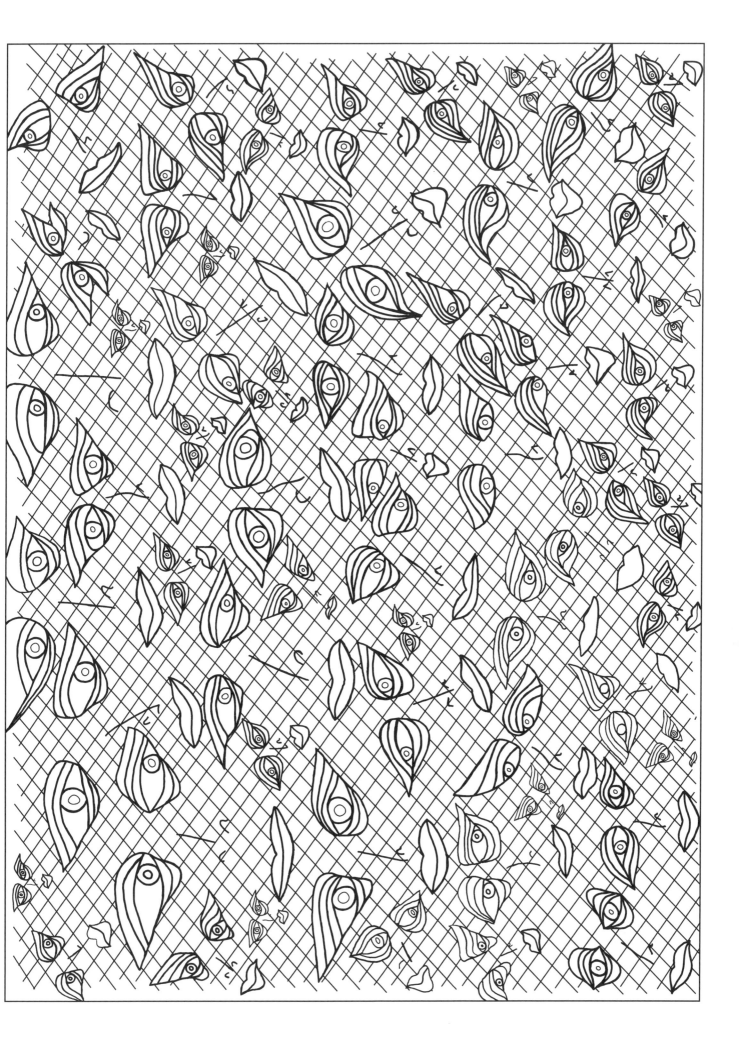

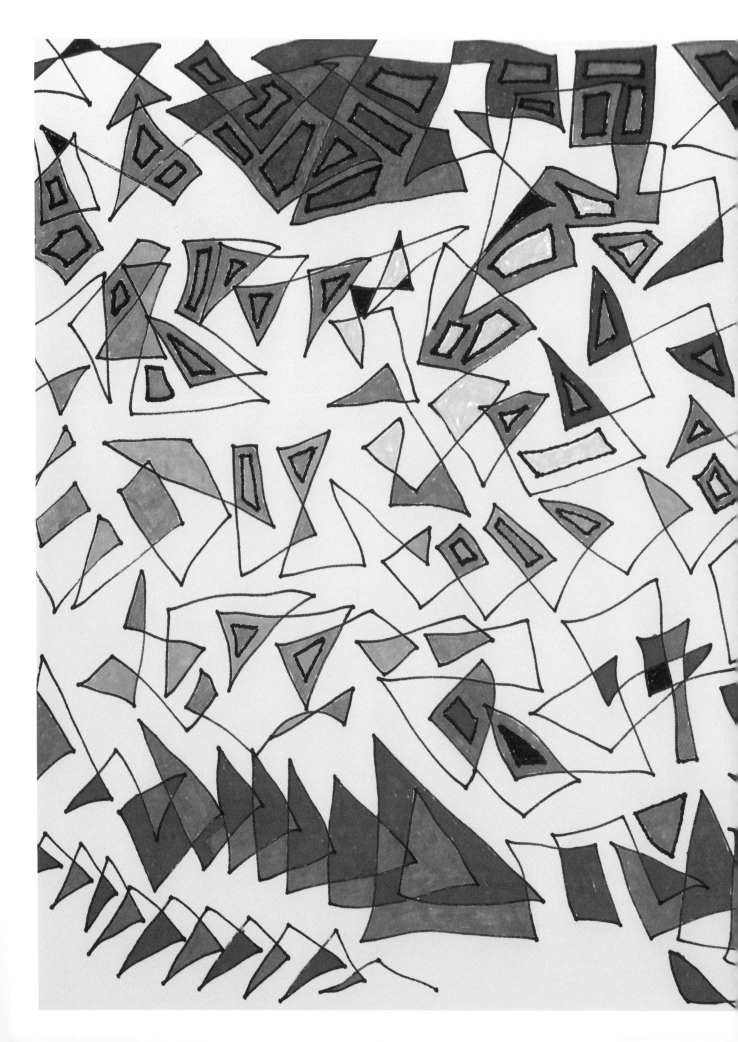

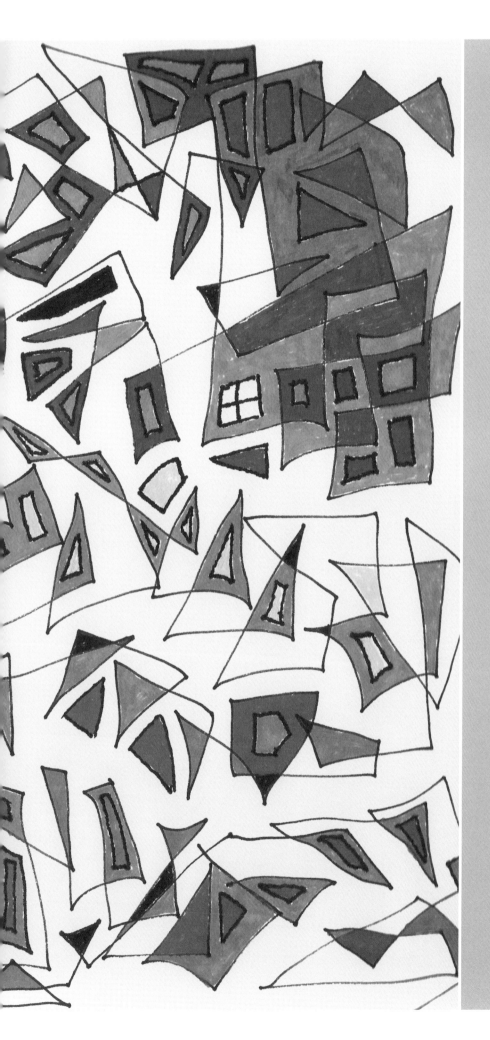

ABSTRACTS

i think the secret shared by many abstract artists is that they too have no idea "what it means." It is just fun to fling color about. The meaning is in the process. Critics may dwell on what is revealed in abstract works—but proving those interpretations is tricky, and perhaps pointless. Maybe the point is fun. And that is certainly the case in this next series of images.

Calder-Type Mobile

Mobiles have always seemed magical to me—floating and diving like "swallows sabering flies before a storm," as Robert Lowell would say. But you do not startle them. You can walk up and touch them—if you are willing to risk setting off an alarm. These mobile-swallow-shapes just seemed to fly across the paper of their own accord.

Fiddlesticks

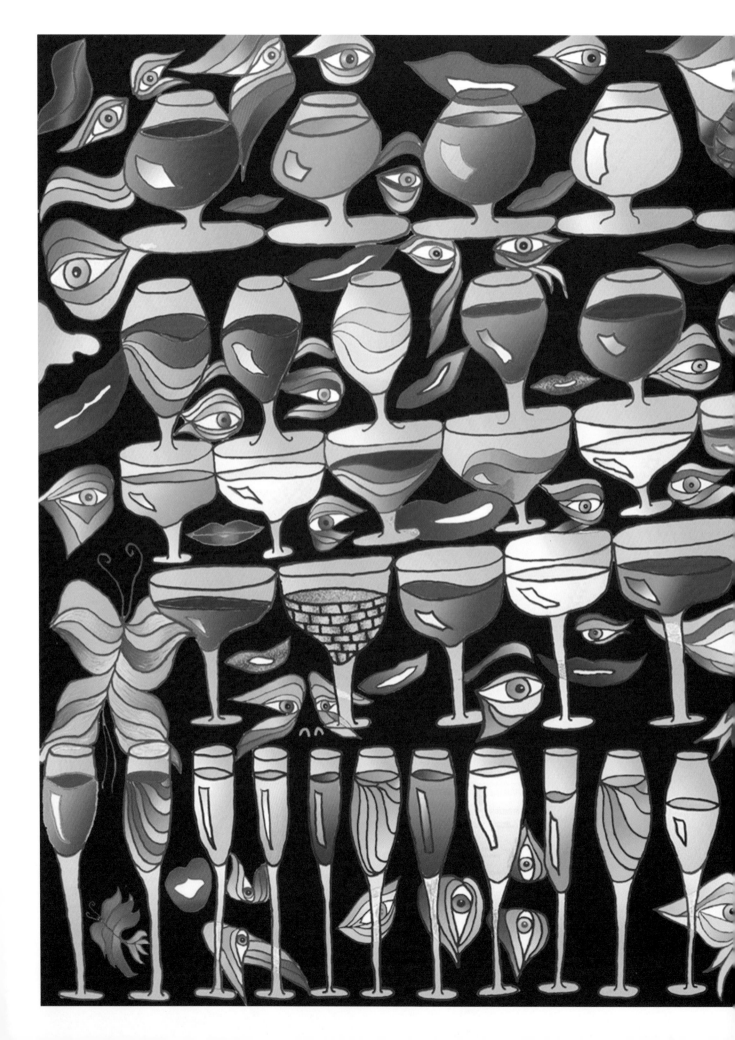

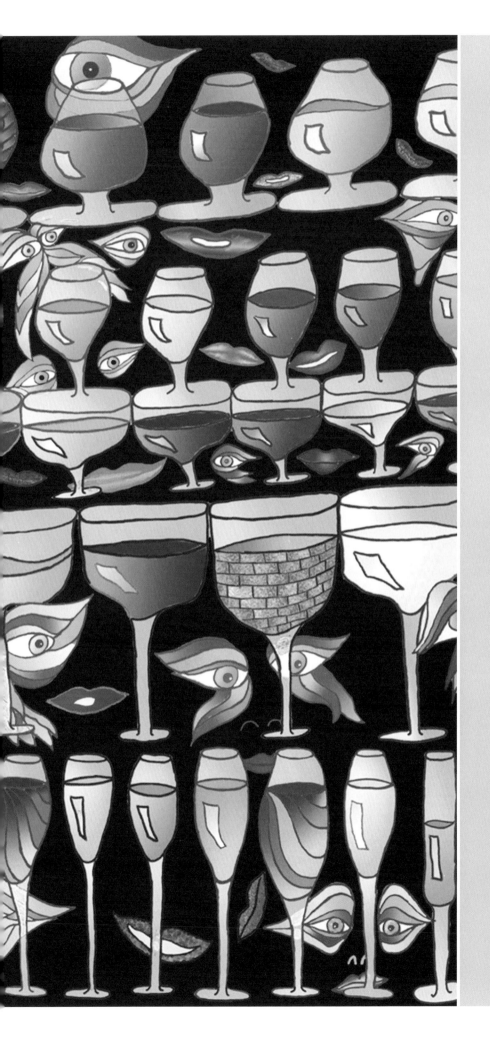

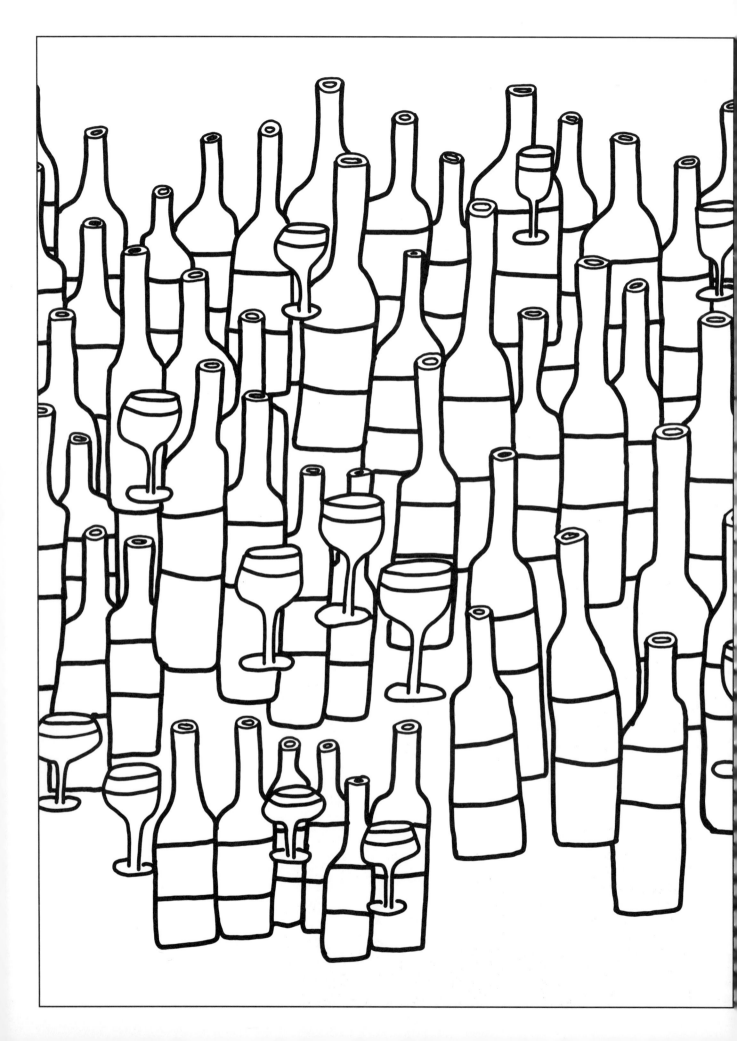

i have always felt that one way to tell a classy place from a dive is the condition of the bottles behind the bar. A well cared for bar shimmers like a Chihuly sculpture; a dive is, well, a dive. Dusty, dirty, shades of a John Ford western or an old biker movie. One thing that makes bottles and glasses fun to draw and color is that they are easy to twist and turn on the paper—and you never have to dust them!

Merry Maitre d'

These bottles strike me as a sort of backwards audience. They are all sitting there behind the bar, looking out over the room, watching us talk and laugh, argue and flirt. And every once in awhile one of them steps forward to decant another round to egg us on.

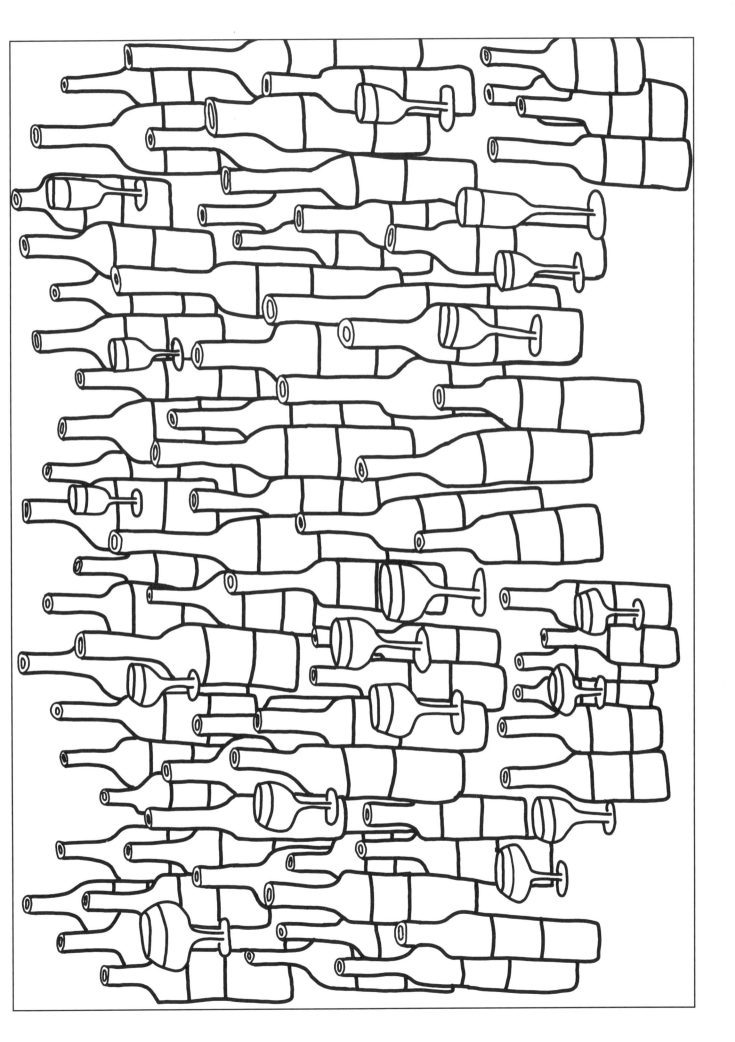

Bottles & Faces Detail

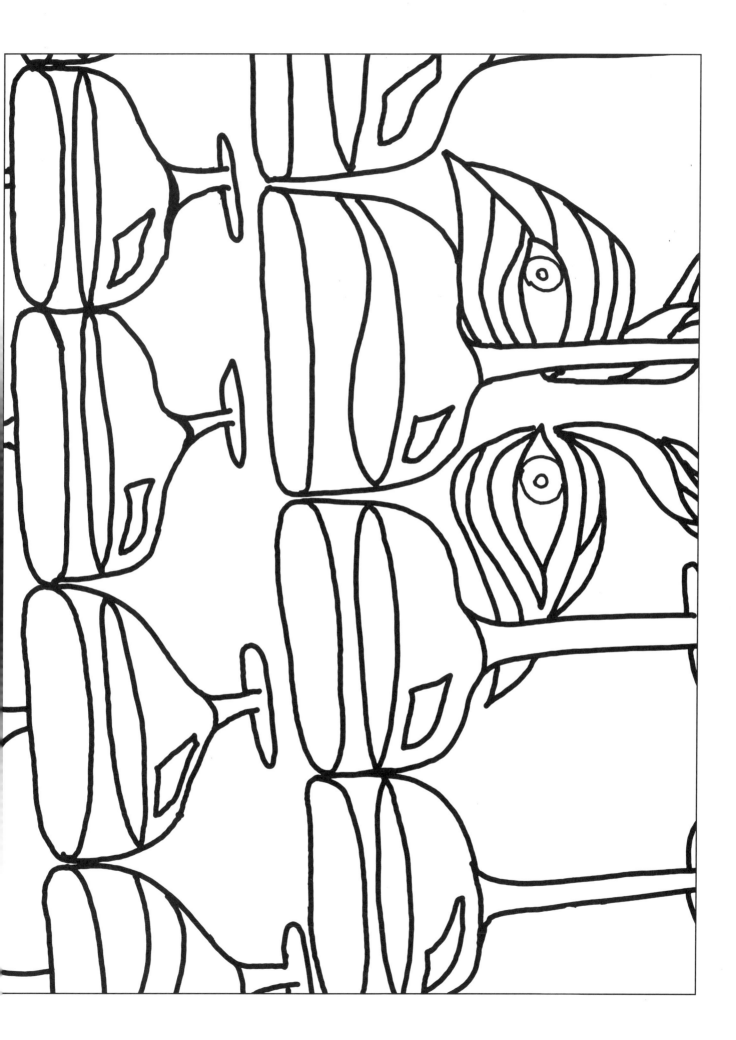

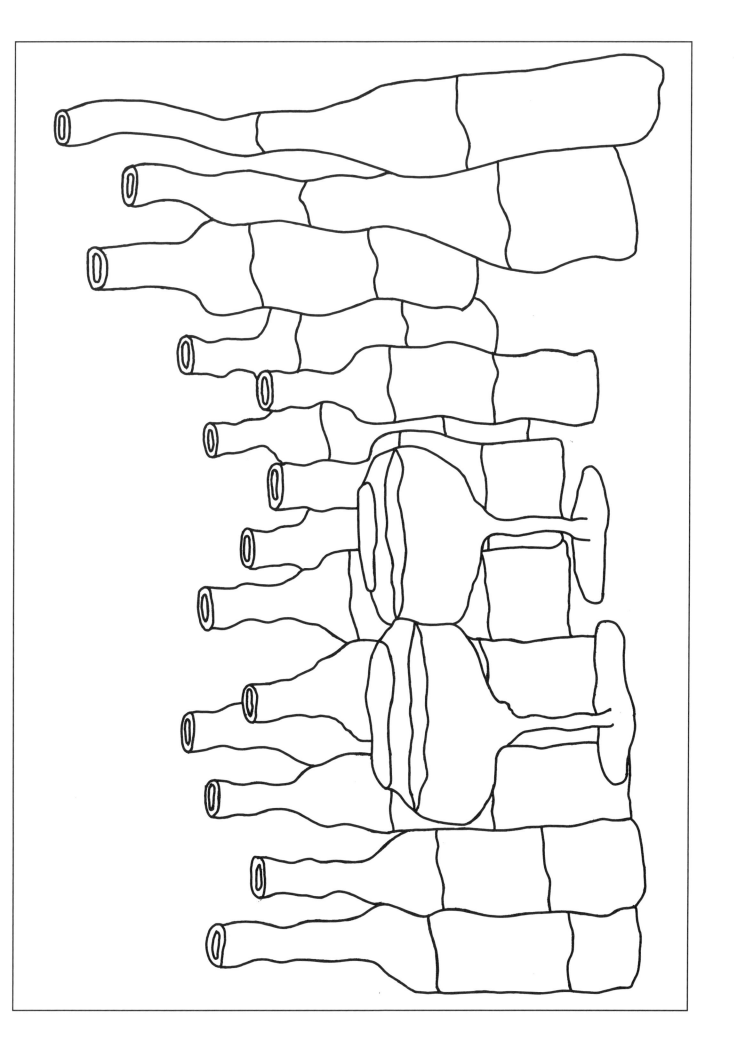

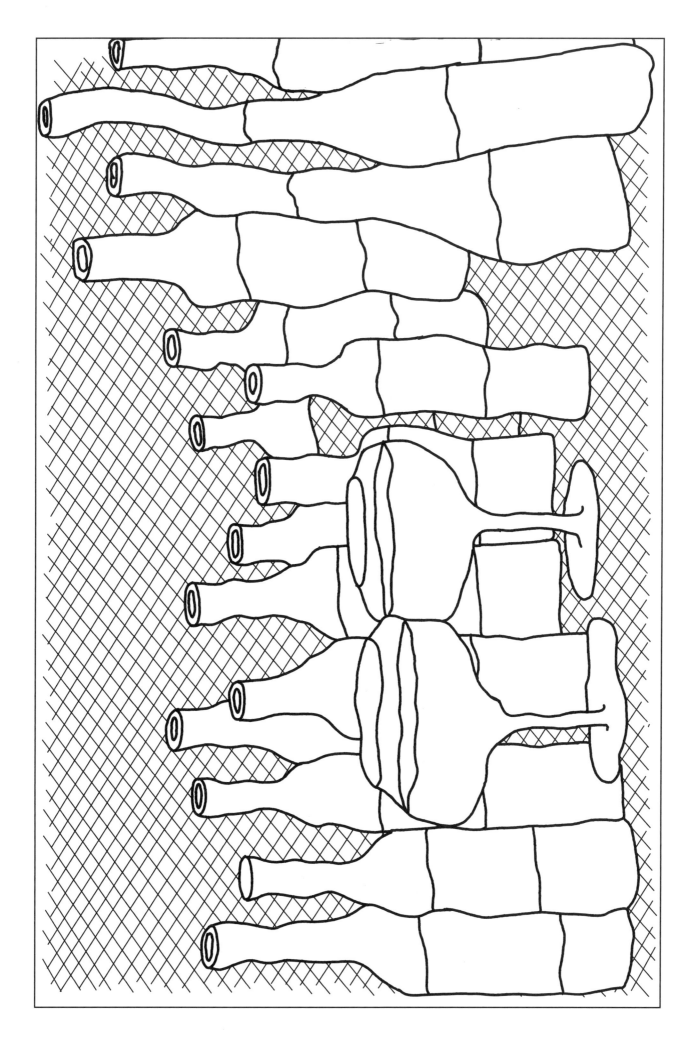

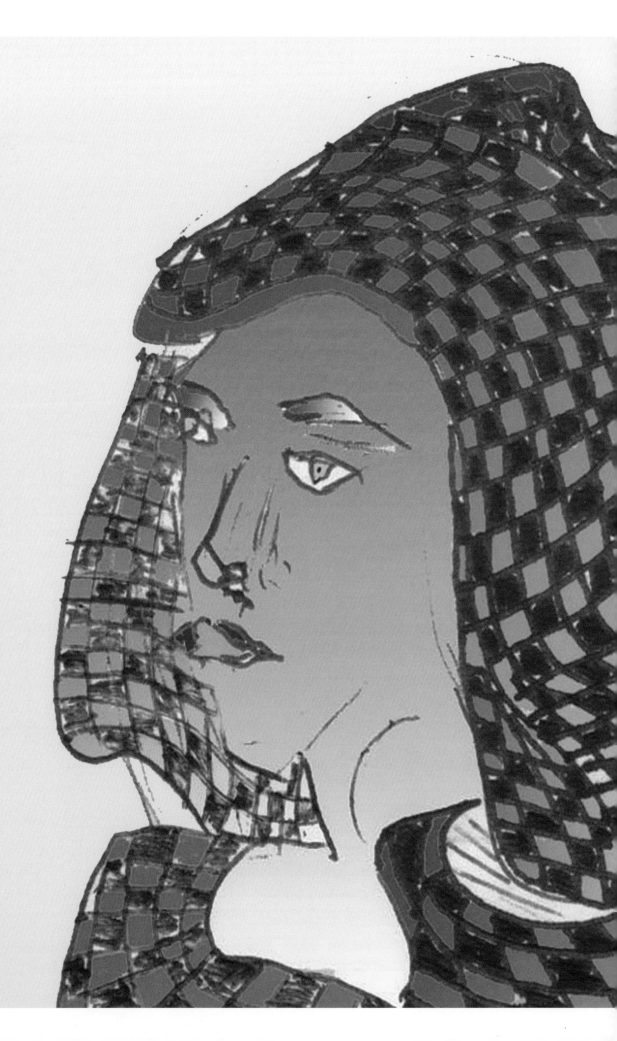

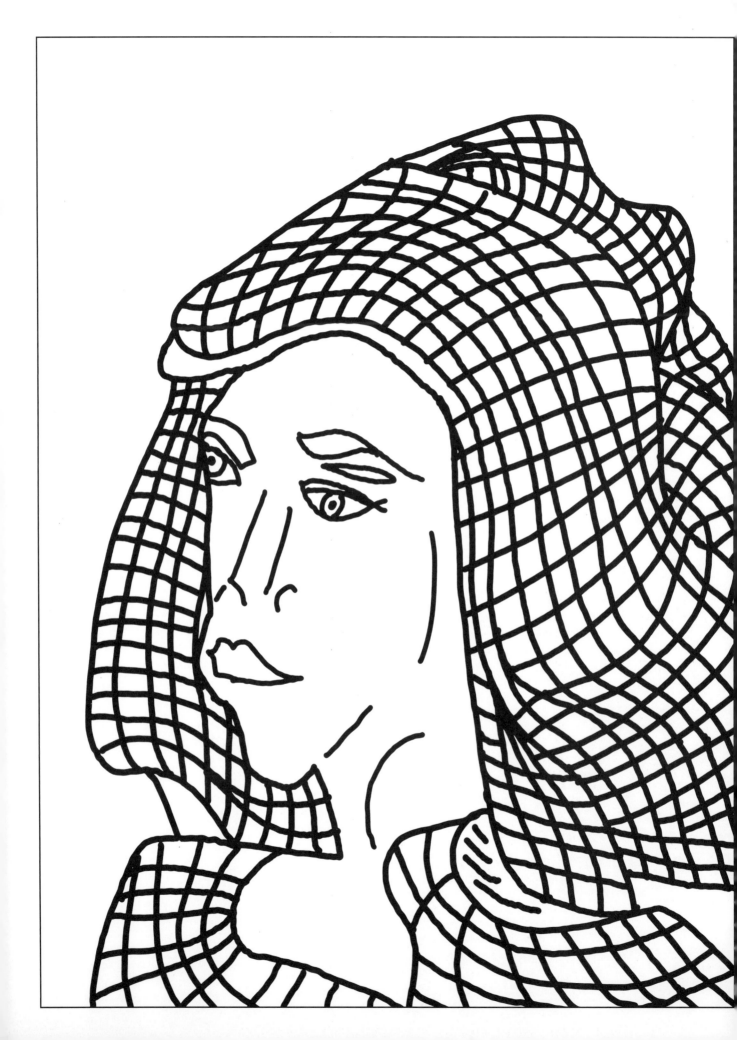

i have heard prose authors talk about how they really don't know how the novel they are writing will end. Louis L'Amour used to talk about how he would jump out of bed in the morning and run to his typewriter so he could see what happened next. I never quite believed it. Until these kinds of images began showing up on my drawing pad. I do not know who they are or where they came from.

Dancing Under the Sea

You see her alone in another image—but she just seemed more engaged when I put her together with a couple of other images.

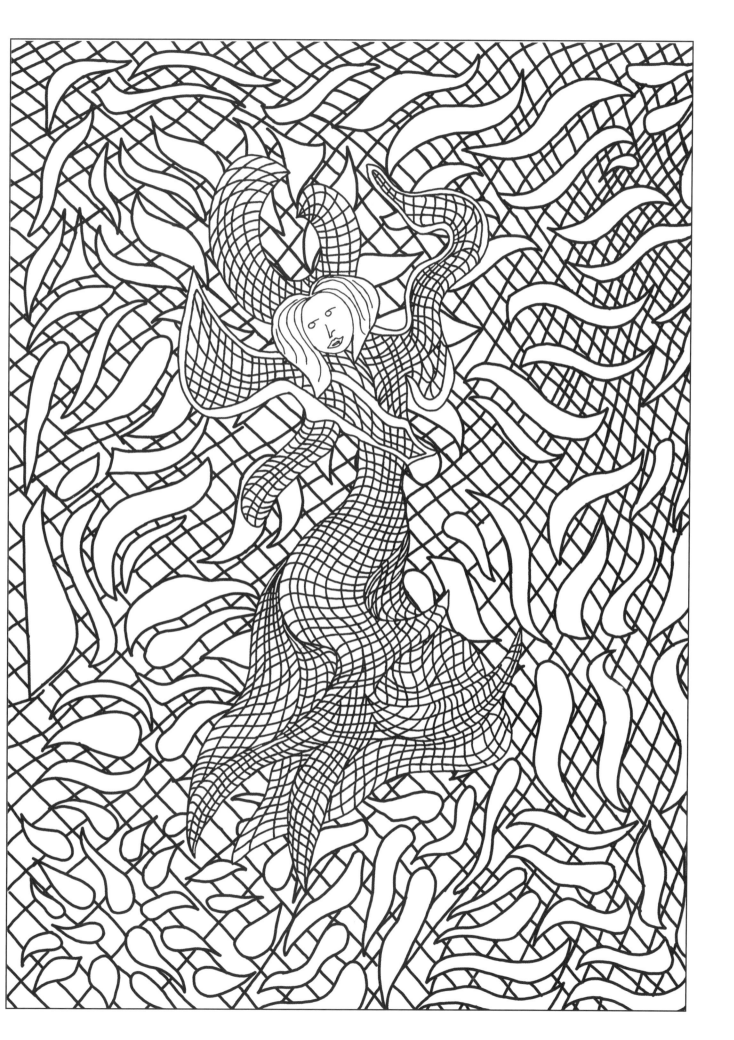

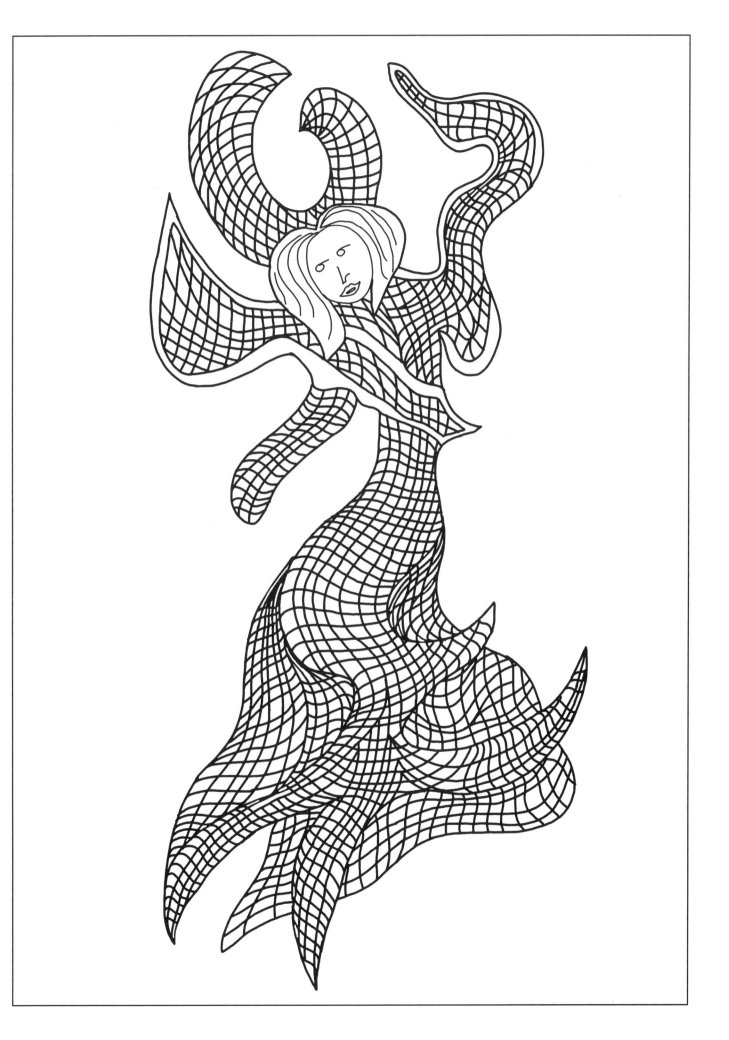

Girl on My Shoulder

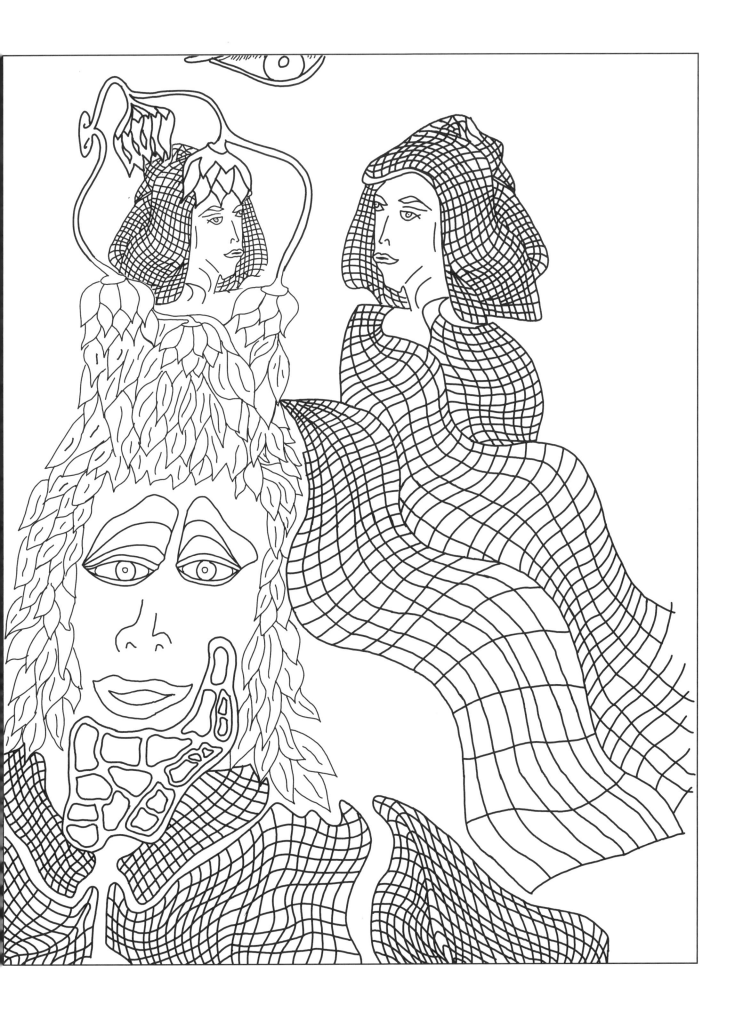

The Musician

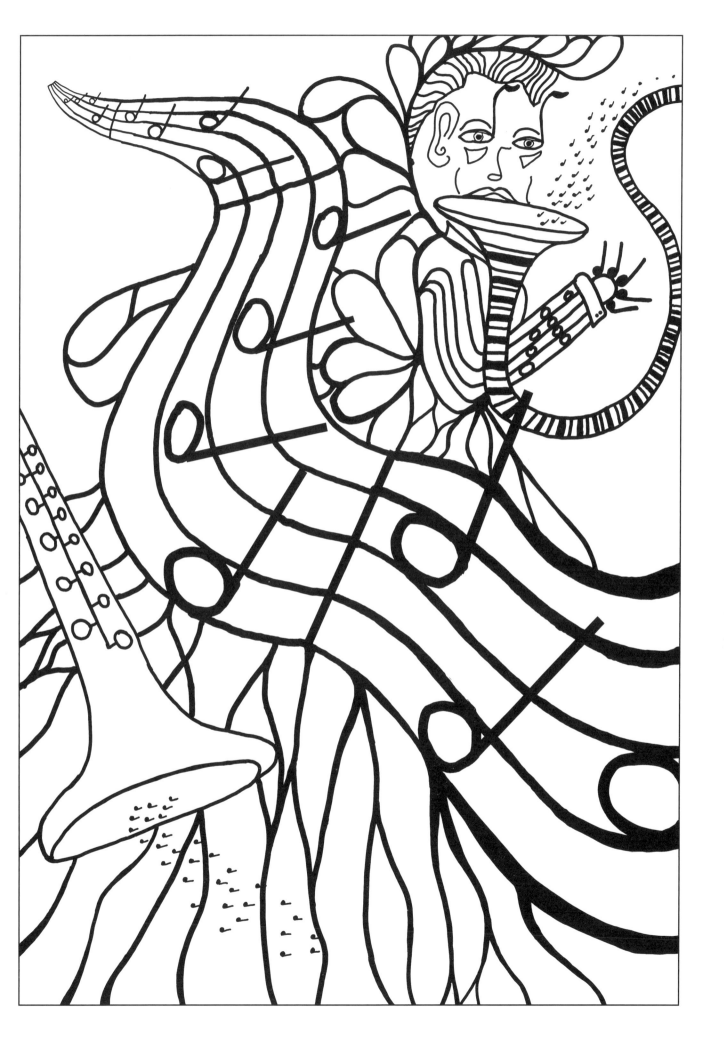

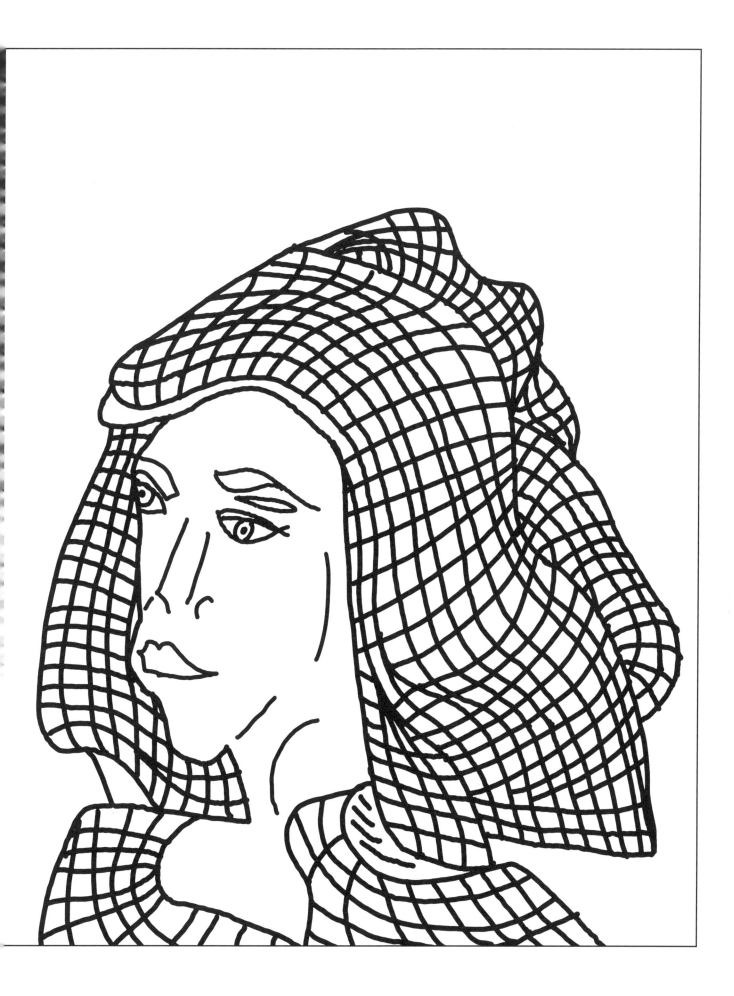

Druids and Bricks

I loved doing the three different patterns: the bricks, the hair and the abstracts. But I had to hide the faces while working on the patterns. They kept staring at me!

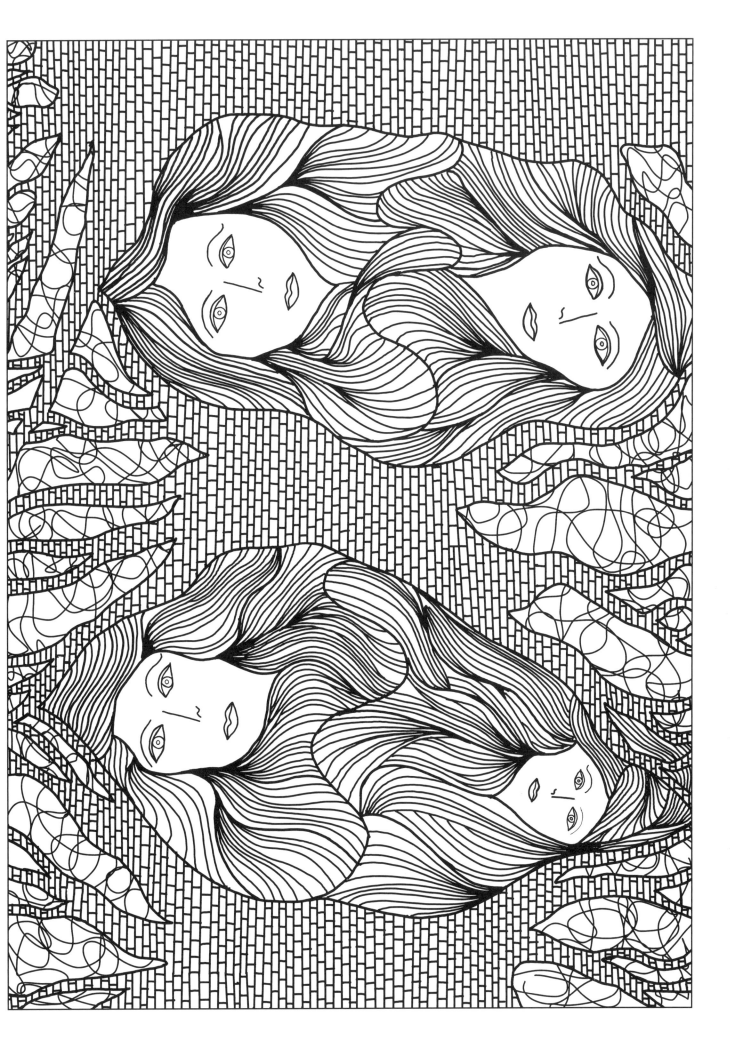

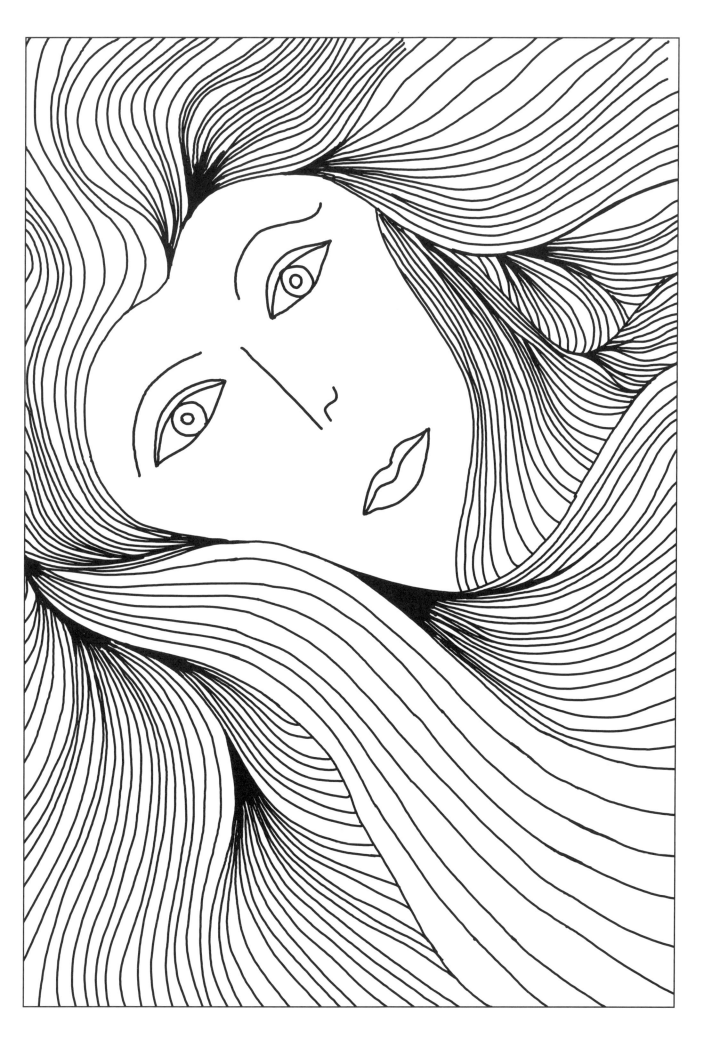

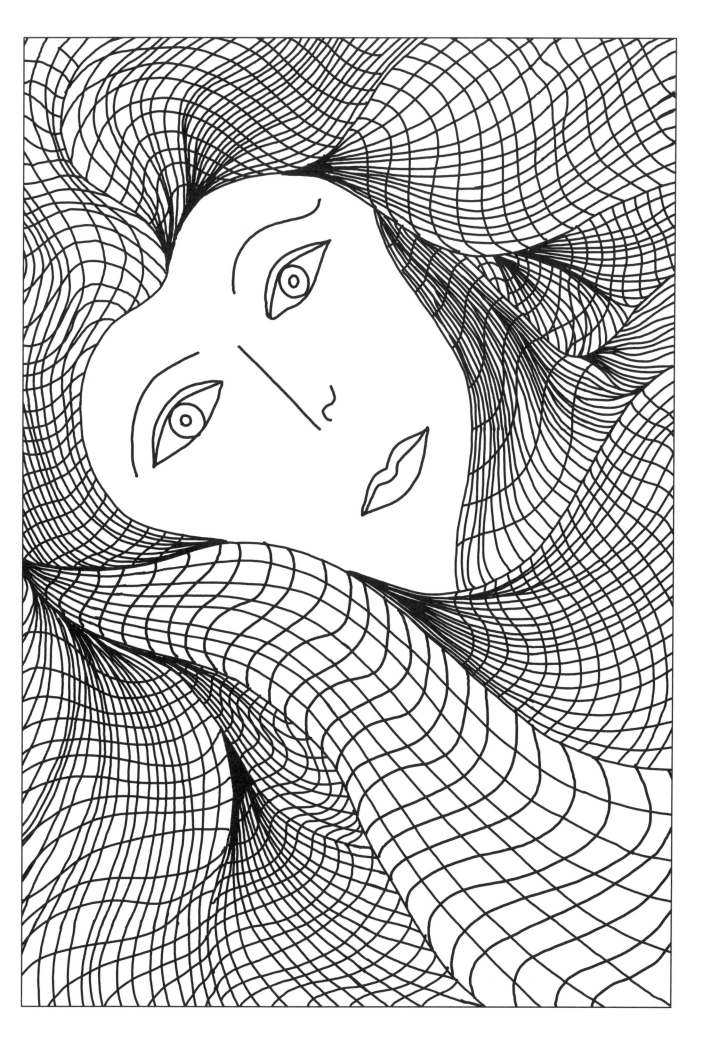

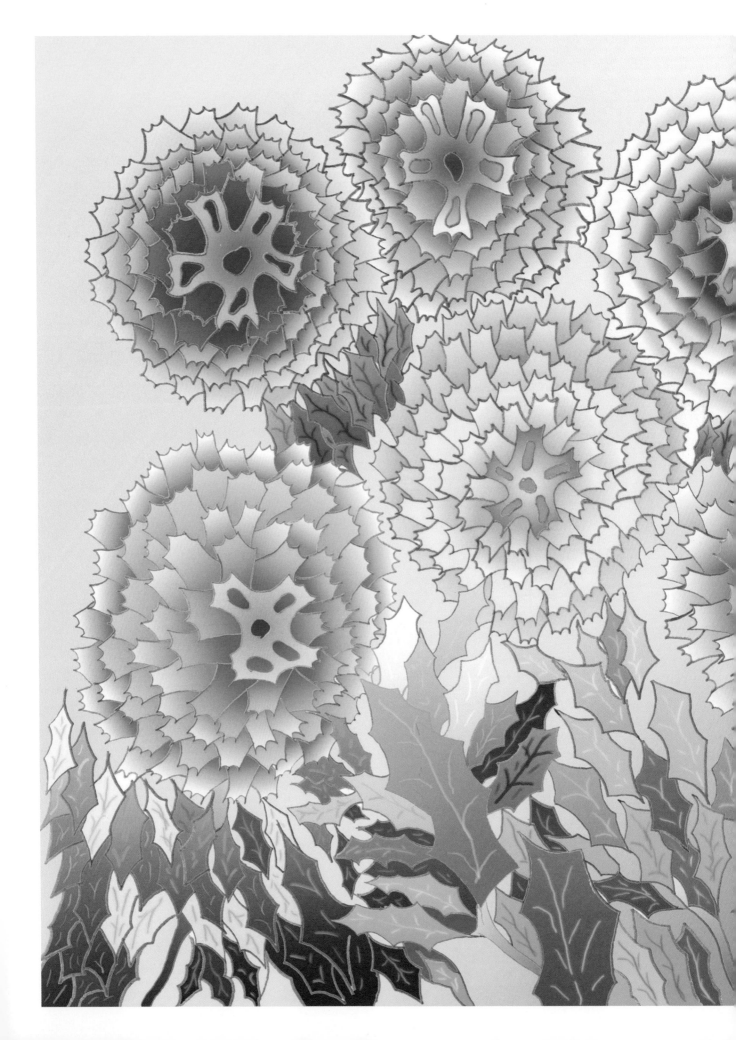

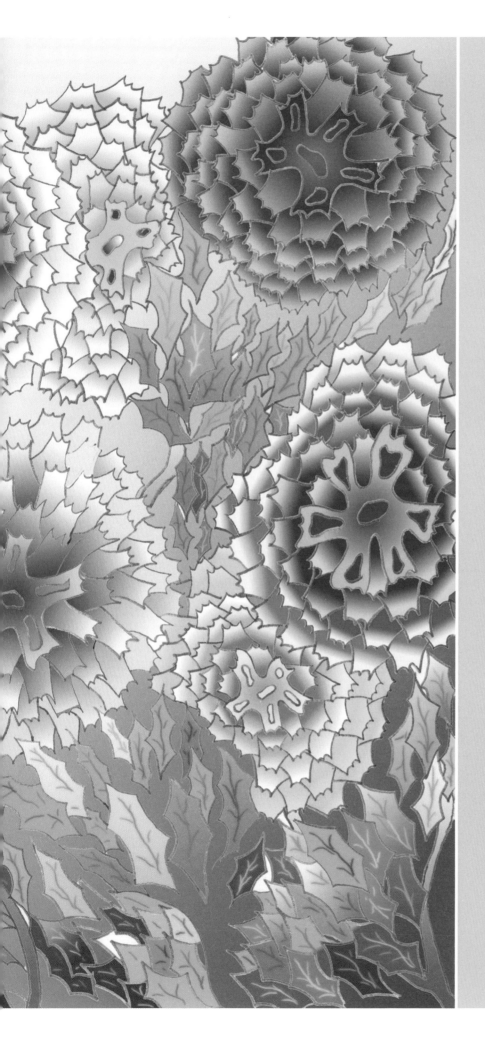

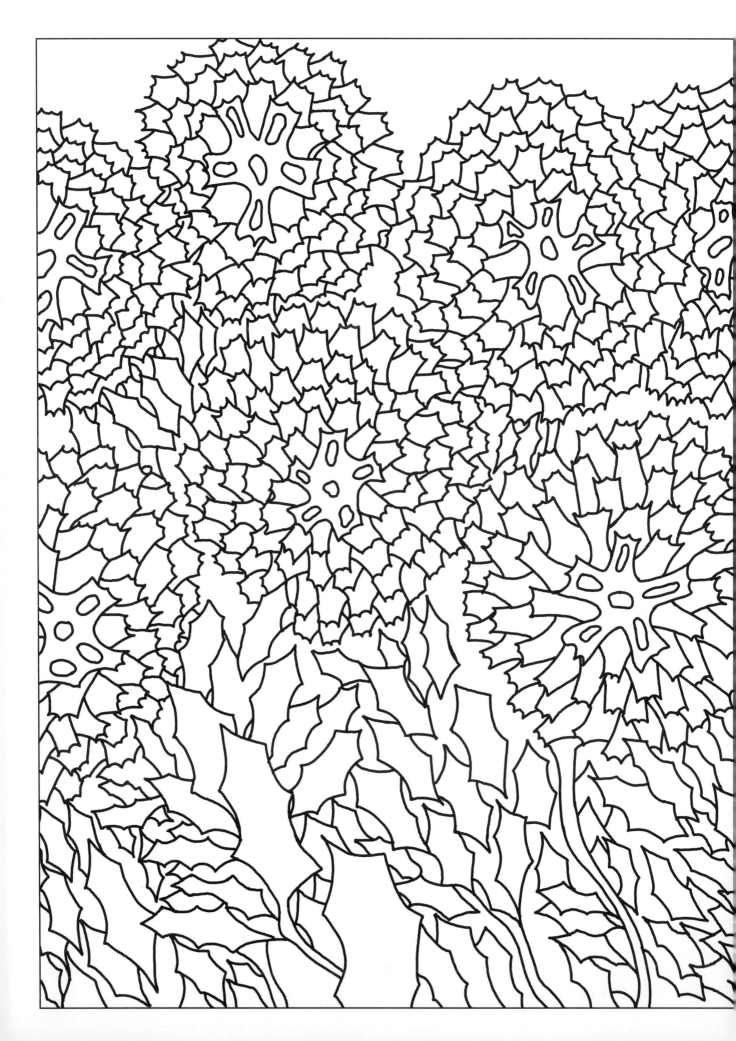

We usually look at flowers from a distance. Perhaps because I am extremely near-sighted I got into the habit, quite young, of getting a "bee level" look at flowers. And when I got close enough for things to "bee" in focus—my, what patterns!

Full Rose

As I was doing this image I came to understand how those Victorian wallpaper designers sort of let things get out of control.

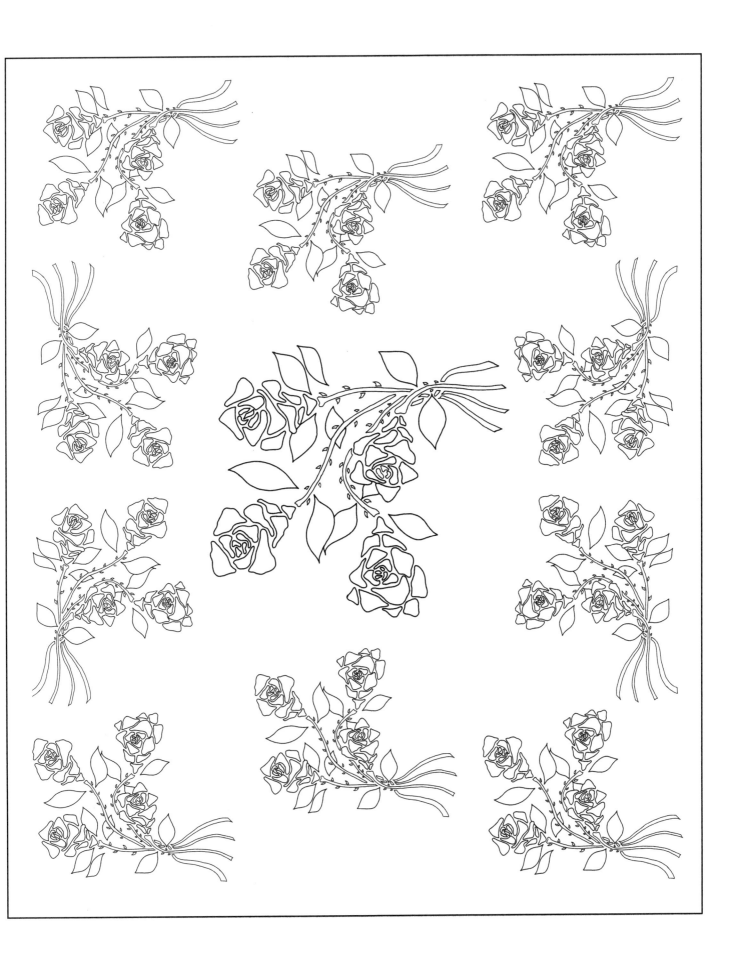

Carnations

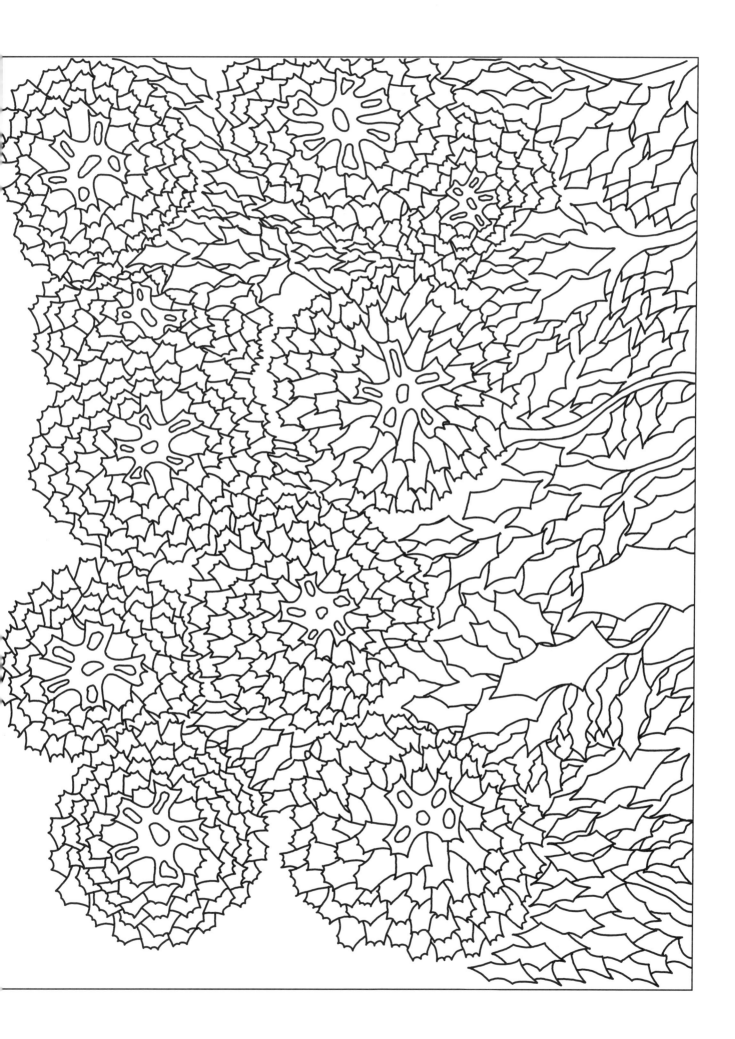

Roses and Thorns

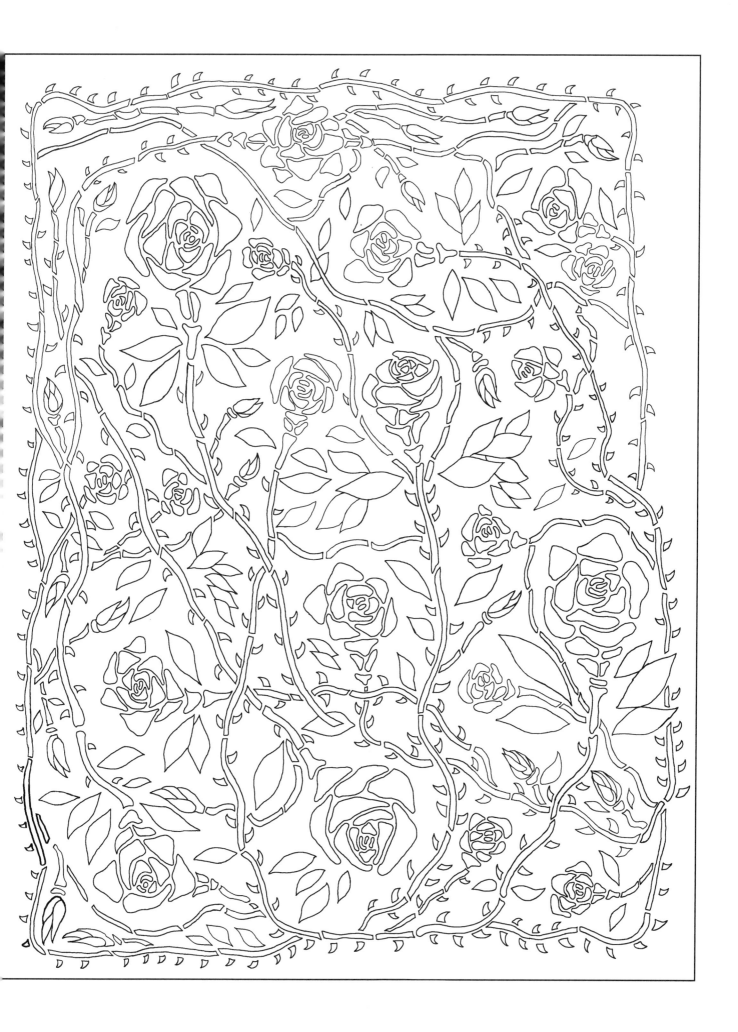

Single Rose

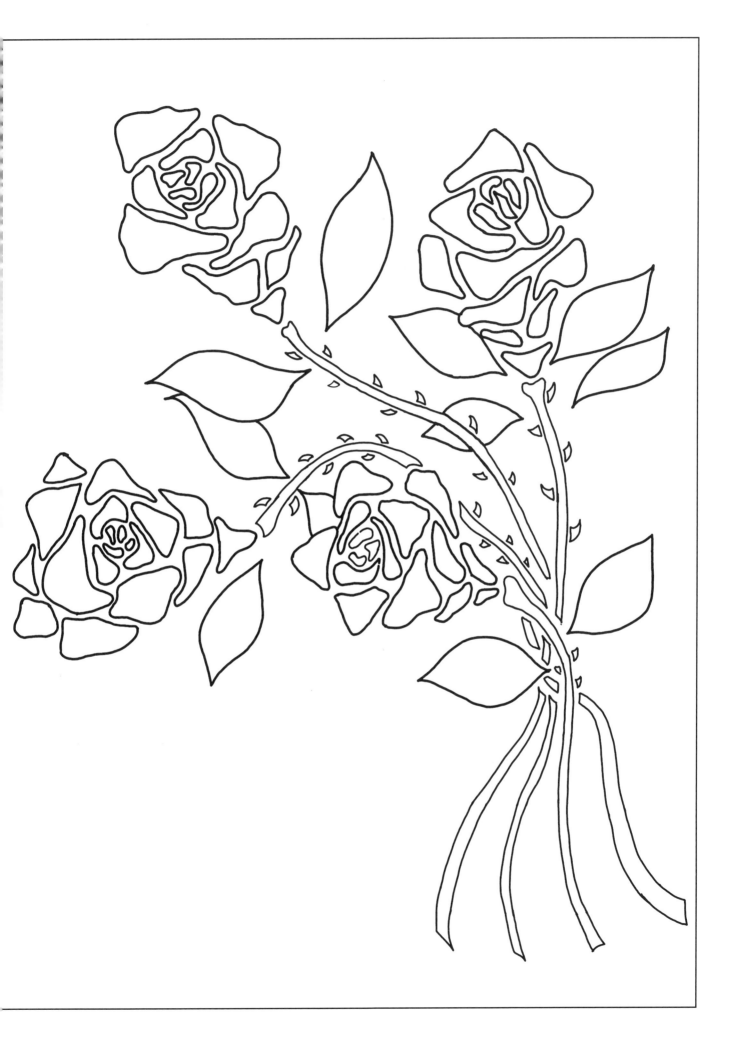

Sunflowers and Rose

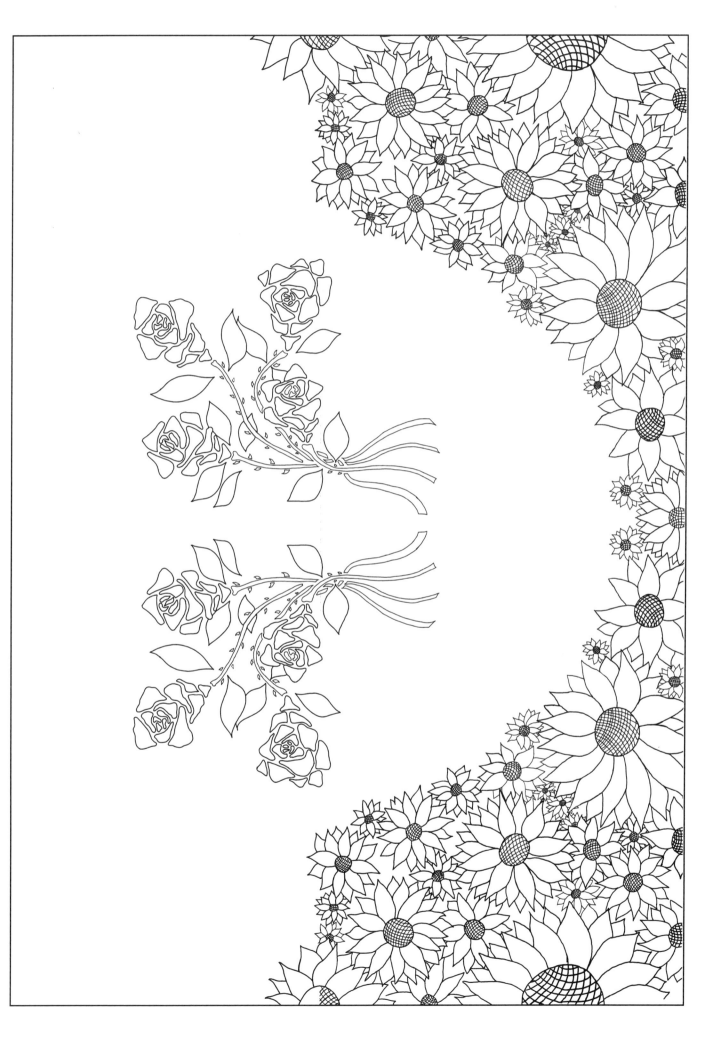

Sunflowers

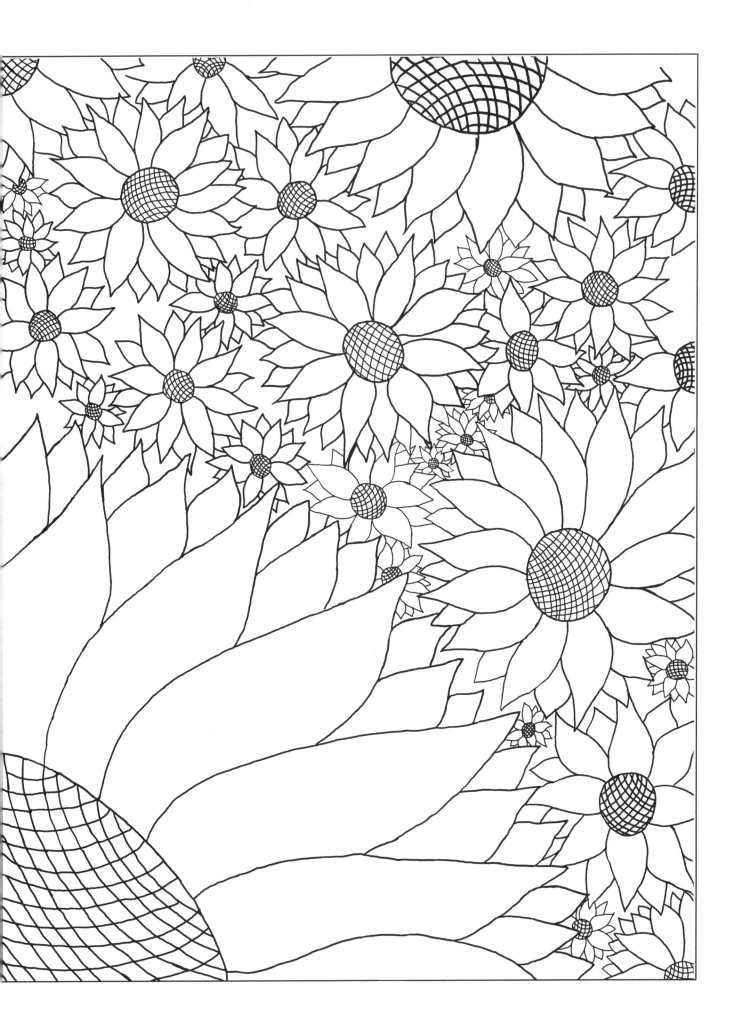

Toasting the Roses

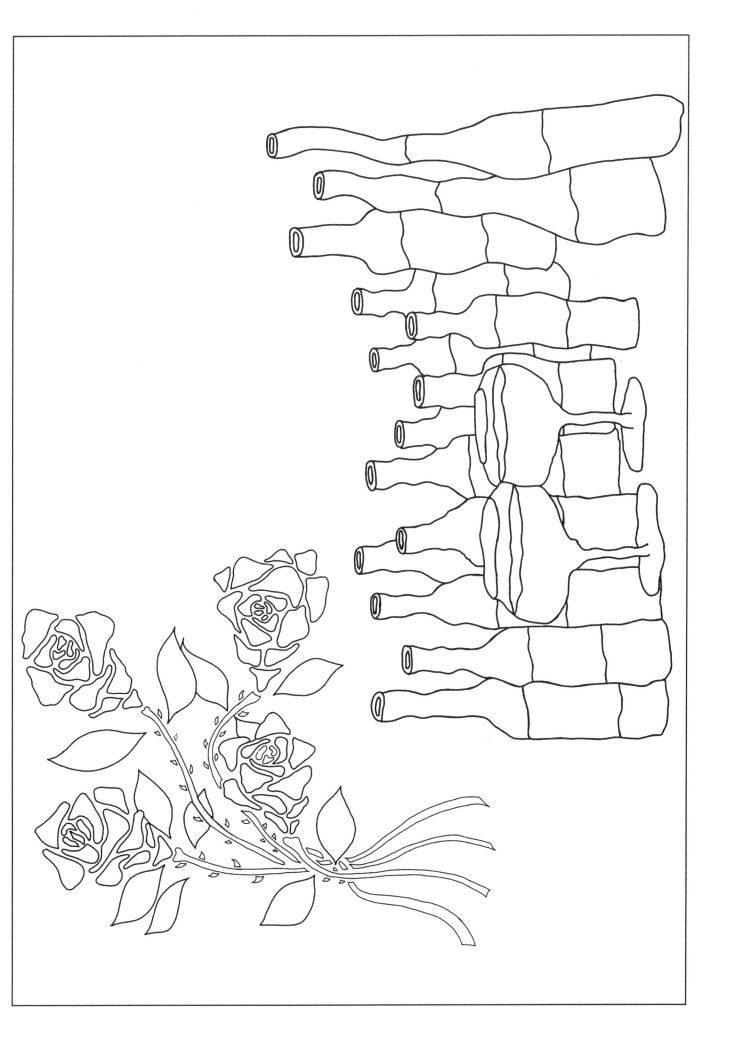

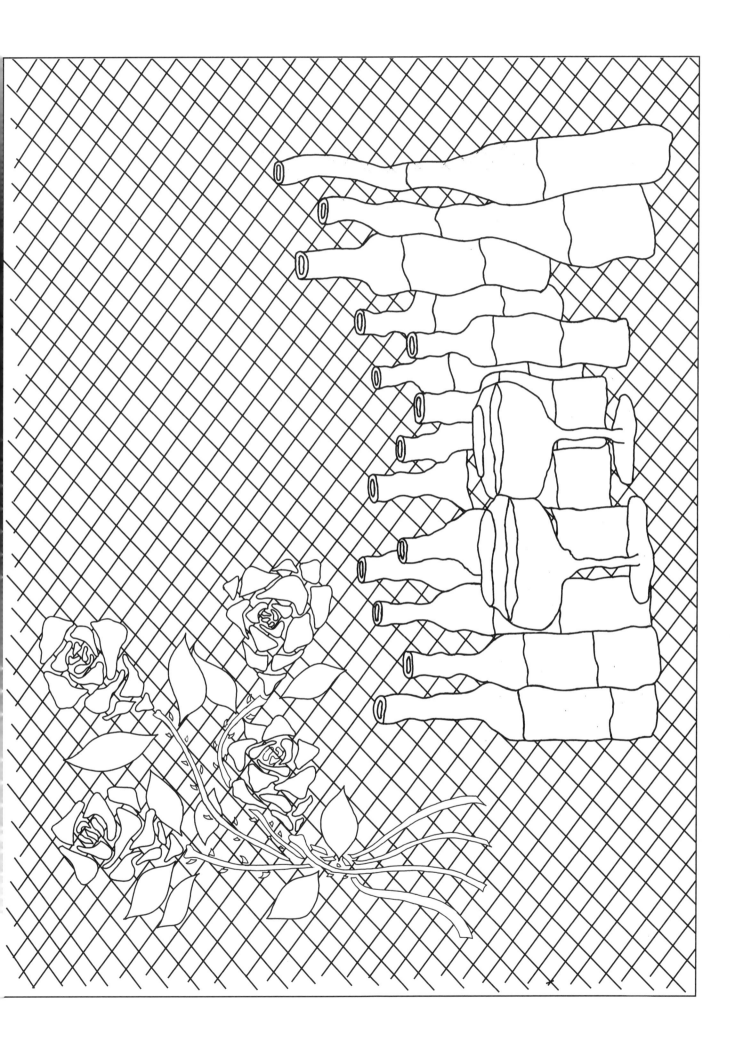

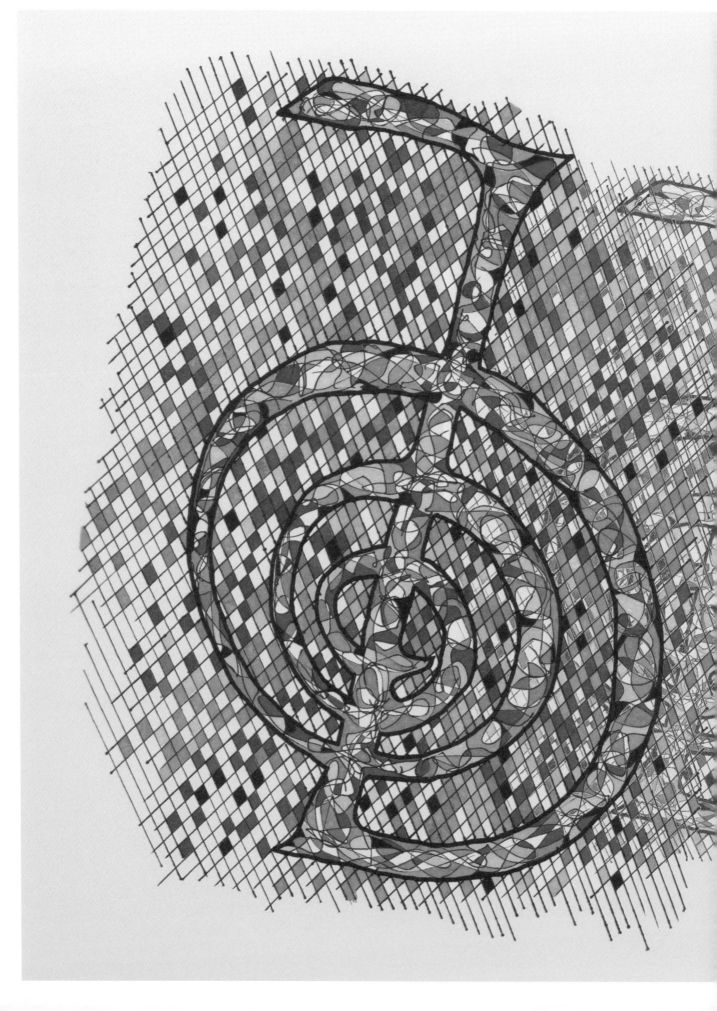

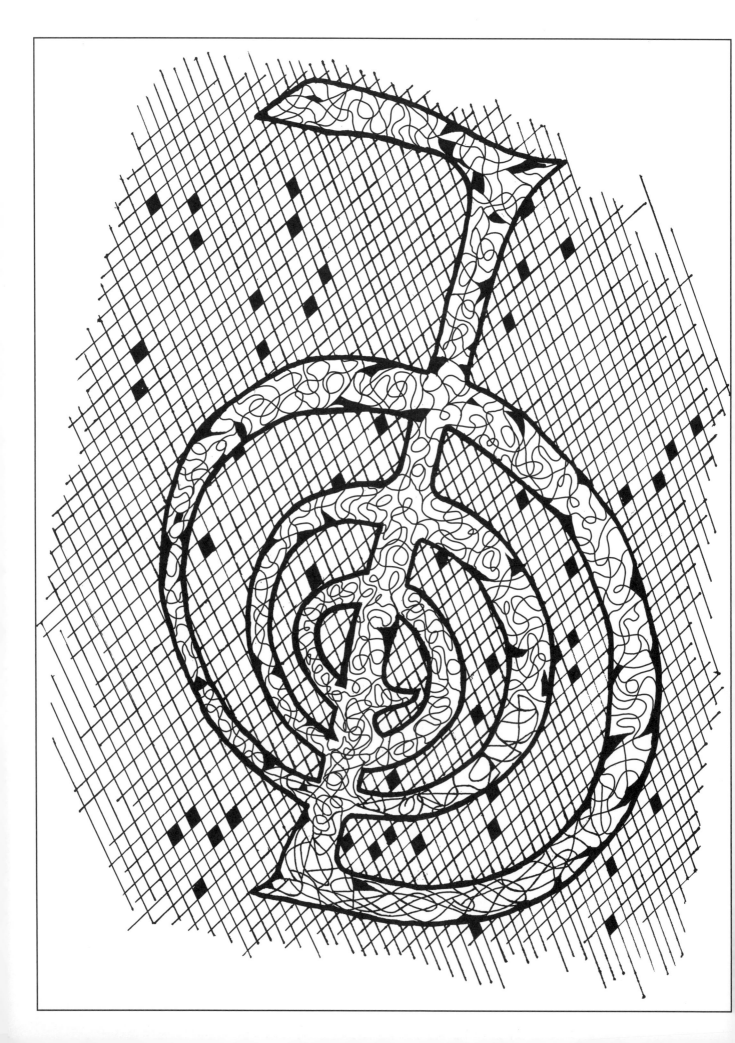

Reike is a spiritual healing perspective that I was introduced to some thirty years ago that eased my first wife's first pregnancy. While I was being trained, the Master running the class stressed that we should never reveal the three major Reike symbols to the uninitiated. Well, the Internet has pretty well eliminated that idea as a search on "Reike symbols" will return almost half a million hits. Over the years I have blended the Reike symbols that I use in my daily meditation ritual with the major tenets of my own worldview. Thus, these next four images are the ones that most closely relate to my worldview. But this book is about the coloring. If you want to know more about the worldview, you can hop over to www.distilledharmony.com. But you can do that later; for now, let's focus on the coloring.

Choku Rei/Foster Harmony

This first symbol, Choku Rei, is the Reike power symbol, the symbol that lends energy to the spiritual healing. In my own meditation I link the symbol to the first tenet of Distilled Harmony which is Foster Harmony. It seems a natural connection since Harmony is the concept that underlies my worldview.

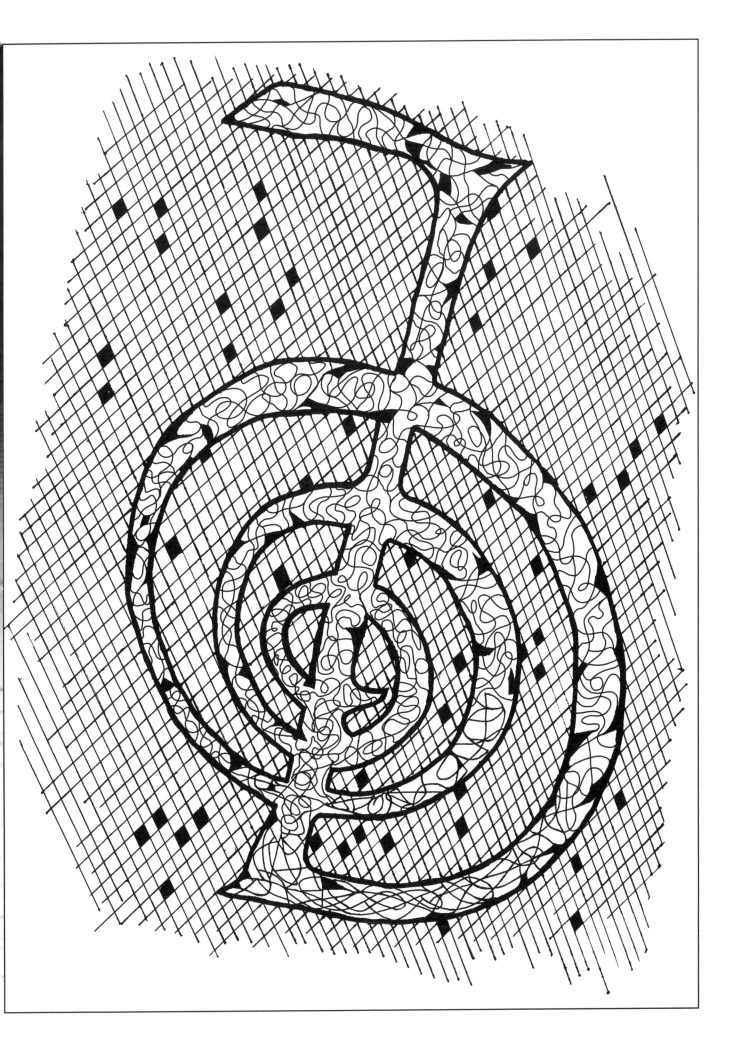

Sei He Ki/Enable Beauty

This second symbol represents the fusion of mind and body in the Reike tradition. In my meditation, the symbol reminds me of the personal obligation to try to make the world a more beautiful place. So it's about the fusion of beauty and our own actions, whether you are sculpting a huge work, throwing your burger wrapping in the trash, or coloring a fun image. This image unites harmony, beauty and your everyday life.

Simplicity/Distill Complexity

I'm sort of bending my own rules a bit here, but they are my rules so I can bend them, right? This third image is actual a kanji symbol that stands for "simplicity." I am not aware of a Reike symbol that carries the same meaning. In my meditation, this third symbol represents the third tenet of Distilled Harmony: distill complexity—or put more plainly KISS (Keep it simple, stupid!). It is an aspect of my worldview with which I have trouble. College professors always seem to walk around with a mouth full of syllables. We tend to use five words when one would do just fine. In my meditation I use this symbol to remind myself to just relax and KISS.

Hon Sha Ze Sho Nen/ Oppose Harm

This last Reike symbol is intended to "heal at a distance," allowing the practitioner to send Reike's healing energy anywhere without regard to time or distance. It breaks down barriers. In my meditation, I link the symbol to the fourth tenet of Distilled Harmony which is "Oppose Harm." The link for me is that most discord in our lives is the result of constructing barriers, either physical, intellectual or spiritual; it's the whole "my way or the highway" idea. We can best oppose harm by doing our best to avoid making barriers or supporting those who do.

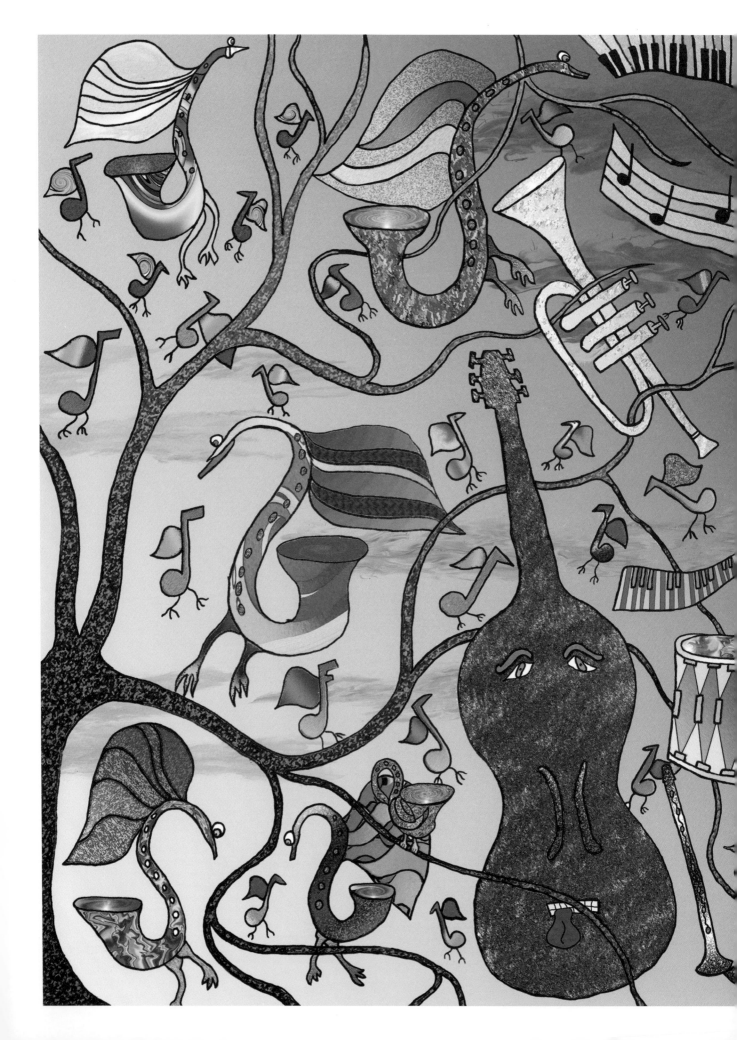

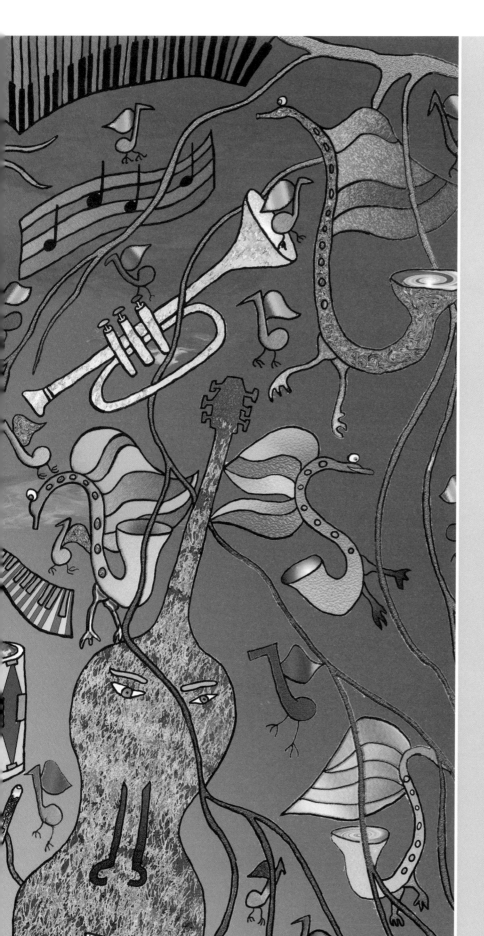

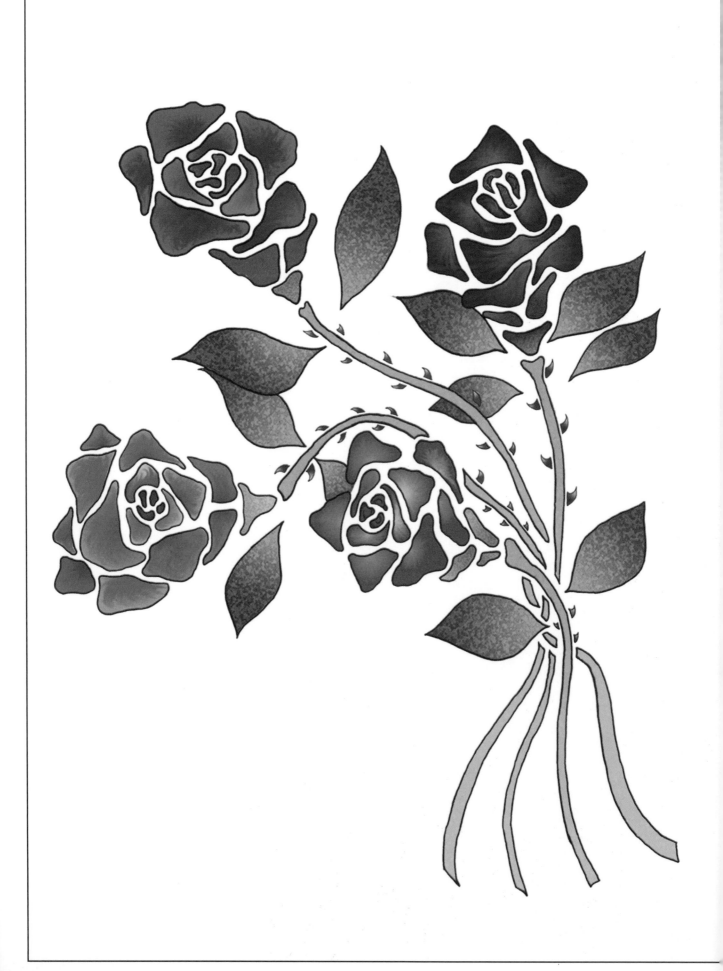

Often people ask me "Who influences your work?"
I think they expect me to respond with the name of an artist or a period or style. I suppose I should research the issue, but in truth the answer is nobody. Each drawing is a unique response to the blank sheet of paper in front of me. If there is a requirement, it is that the thing with which you draw—marker, pencil, stylus, whatever—should glide smoothly over whatever you are drawing on. You, not the materials, should decide where the line goes.

Obviously, I get fascinated with particular shapes and forms. Eyes, glasses, grids, bottles, triangles, musical notes: All get their time in one drawing or another. But once the form has taken over a page, the composition is pretty much freeform. The best rule is "No Rules." Particularly when it comes to color.

I have put these colored examples into the book not to show you any guidelines for proper coloring, but rather to demonstrate that there are no rules to proper coloring. Any color can go next

to any other color as long as it makes you smile. I always try to pay particular attention to sunsets. Really bright, deeply-colored sunsets. They are just outrageous when it comes to "color choice." They will slap the most clashing colors right up next to each other, and yet somehow the overall impact is just beautiful. I figure if it is good enough for a sunset, it is good enough for us.

When thinking about color I need to point out that putting color onto the page in the book is not the only way to color the pictures in this book. Please feel free to scan the black and white pages and then color them digitally. I have a graphics tablet that, in conjunction with Photoshop or a similar graphics package, really blends the calming effect of moving your hand across a page with the flexibility that digital coloring brings—millions of colors and layer by layer "undo" functions that let you experiment with lots of different options before committing to a finished look.

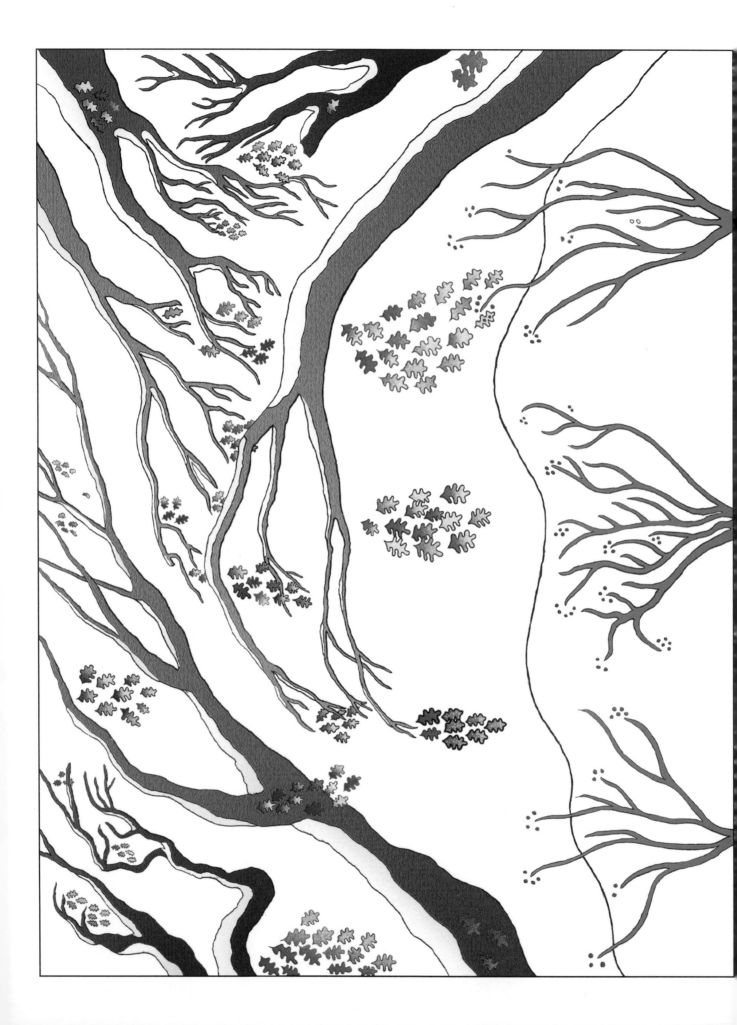

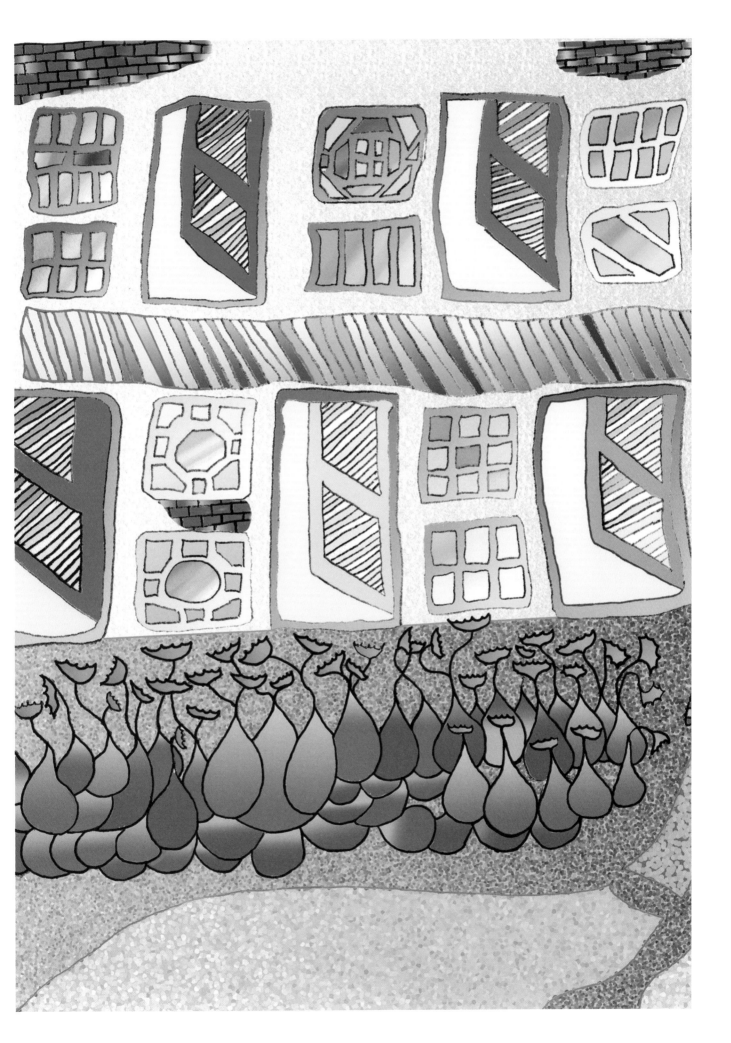

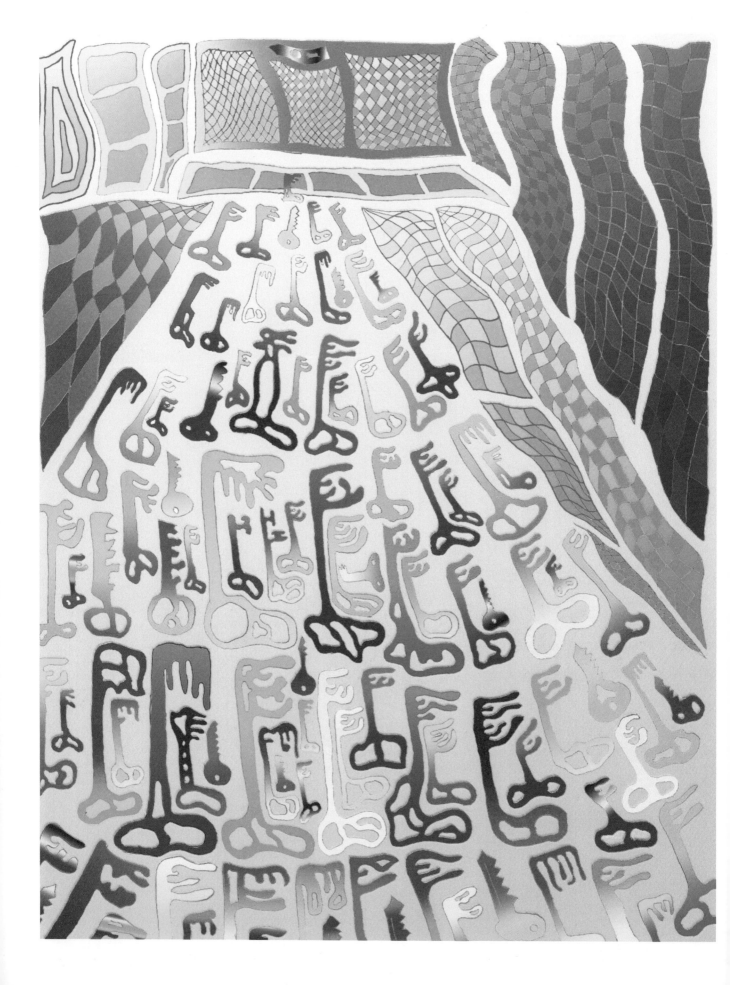

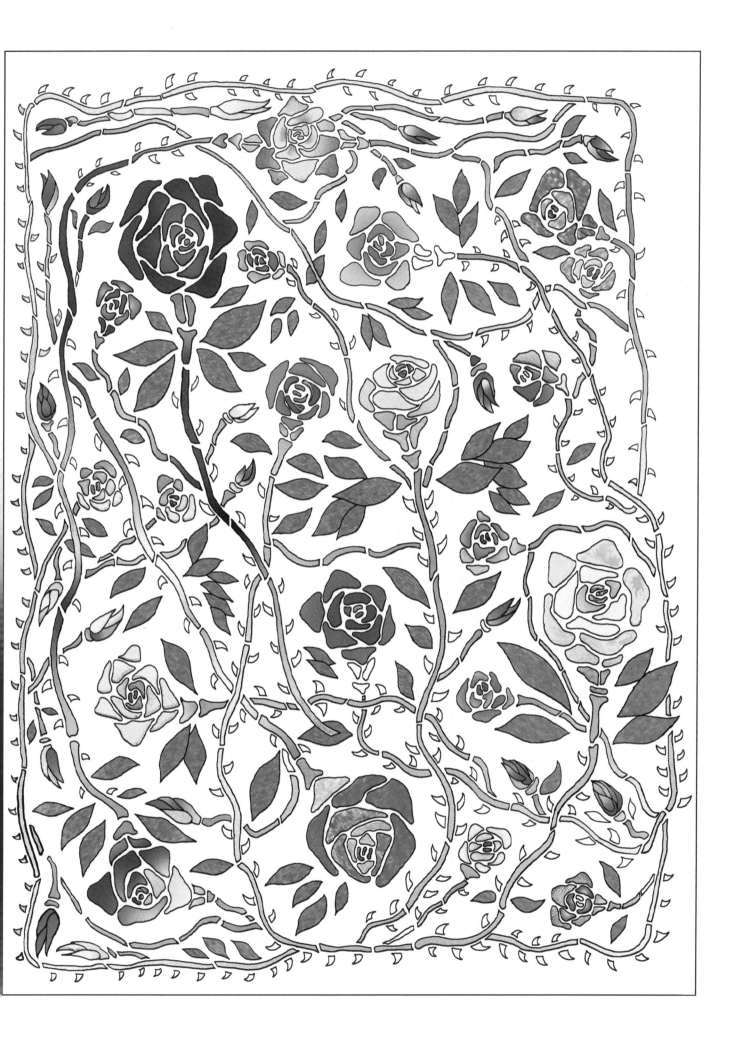

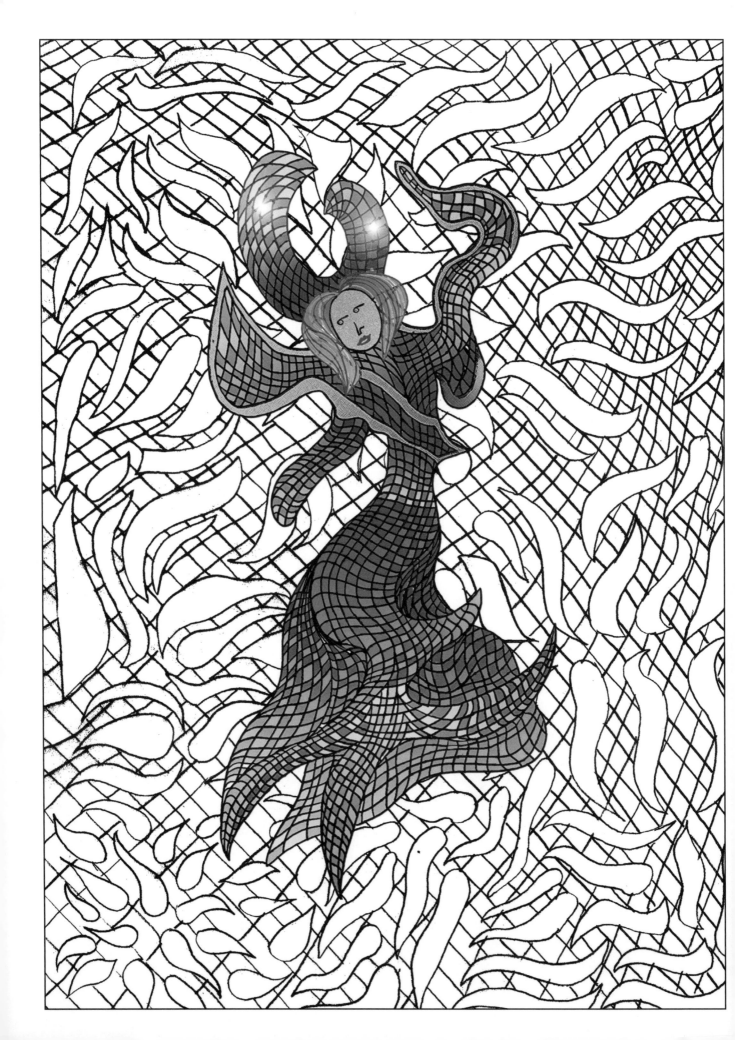

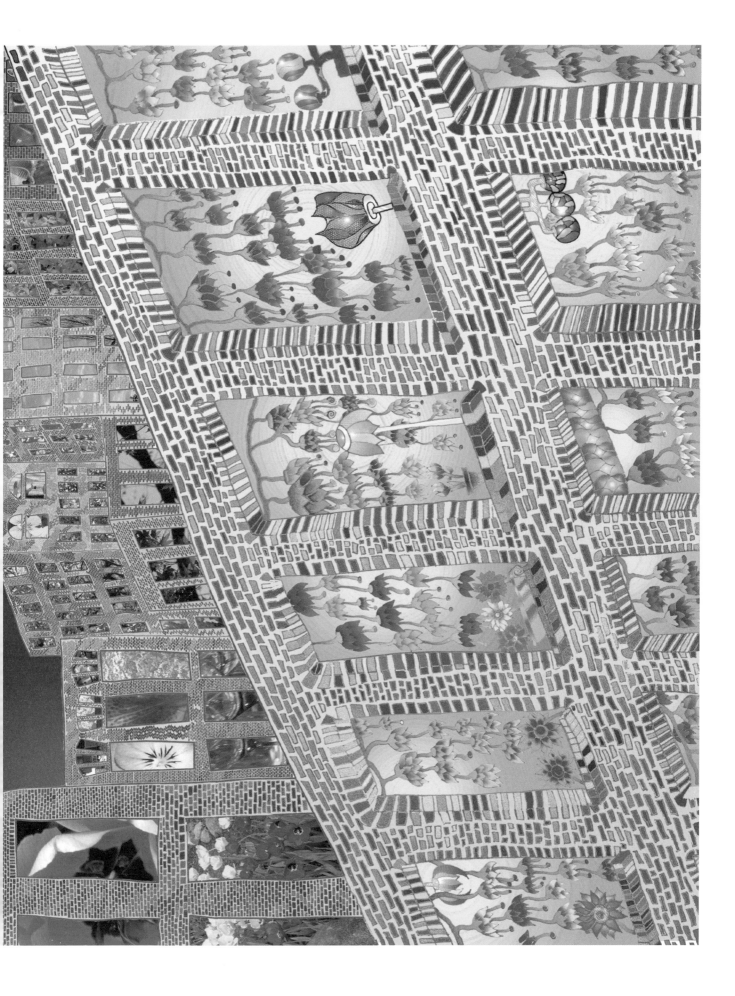

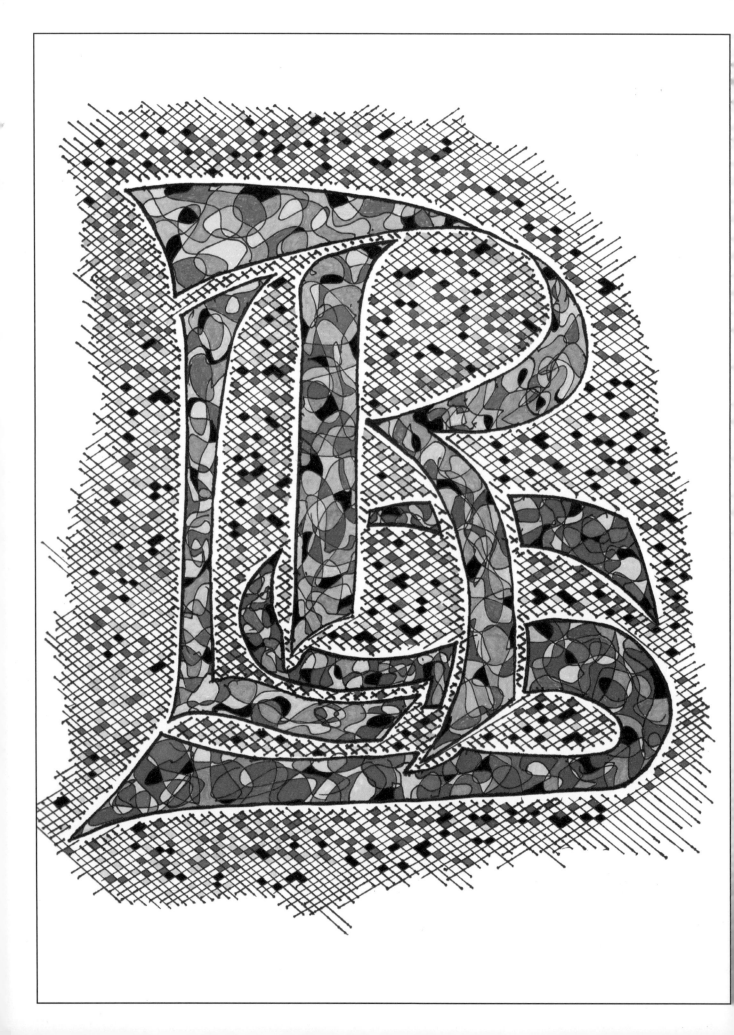

I remember, as an adolescent, practicing my signature.
I mean, I suppose there is a time in everyone's life when they assume they will someday be famous. As a stagestruck kid, that was a given. Playing with a monogram is my more adult, or perhaps second childhood version, of that pastime. This image is the result of just playing with my monogram until I found one that was visually pleasing. Then I "fattened" the letters up on a big sheet of drawing paper and "doodled" them until this came out.

It strikes me as an appropriate way to sign off! Thank you so much for spending your time with me and my drawings.

Cheers,
RL Schrag

About the Author

Hello my name is Robert Schrag and I am a professor of communication at North Carolina State University in Raleigh, North Carolina. I came to NC State University in 1980, so I've been doing the professor thing for quite a while, and I will continue to do it for as long as it remains enjoyable. This book, however, has little or nothing to do with that profession. You see, ever since I was a small child, I have been forever ambushed by moments of pure harmony. Moments when I seemed to be entirely in tune with the world and my life. As I grew older, I came to realize how rare and precious those moments were. I tried to capture them in words, in music, in dozens of different ways. This book pulls together a few of those harmonic moments in words and pictures—pictures that started out as mine, but can now become yours as well.

Dedication

While the creation of the black-and-white drawings can take shape relatively swiftly, the calming, meditative coloring process is, by design, a time-intensive activity. It is also usually a solitary activity, one that turns you inward to your calm center. That, by definition, can turn you away from the people with whom you spend your life. Hence, the primary dedication of this work needs to go to my dear wife Christine, who loves me enough to be amazingly tolerant of my regular retreats into the calming world of coloring.

A second dedication has to go to my older daughter Andrea, who during the course of a phone conversation told me about an "adult coloring book" that she had ordered, and wondered why I didn't make one out of my drawings. I thought about it, and did. Thank you, Andrea!

Acknowledgments

Life in the twenty-first century often demands we compartmentalize our existence: one silo that contains what we do for a living, and another that holds those activities and individuals that we cherish while alive. Opportunities to blend the two are rare, and those who aid in providing those opportunities should be recognized. During the past decade, when my drawing has become an important tool for clarifying and sharpening my own thought processes, it took an exceptional colleague to realize that "doodling" during meetings actually allowed me to focus on and better contribute to discussions that might otherwise border on the tedious. Dr. Ken Zagacki has served as our department head at North Carolina State University for that time period, and has never failed to graciously ignore the ceaseless sketching going on down at my end of the boardroom table during such meetings. Thank you, Ken.

Thanks are also due to the good folks at North Light Books who have been so supportive in bringing these thoughts and images to you: editor Kristy Conlin, designer Clare Finney, and production coordinator Jennifer Bass. Thanks all!

Metric Conversion Chart

To convert	to	multiply by
Inches	Centimeters	2.54
Centimeters	Inches	0.4
Feet	Centimeters	30.5
Centimeters	Feet	0.03
Yards	Meters	0.9
Meters	Yards	1.1

a content + ecommerce company

Other fine North Light Books are available from your favorite bookstore, art supply store or online supplier. Visit our website at fwcommunity.com.

20 19 18 17 16 5 4 3 2 1

Distributed in Canada by Fraser Direct
100 Armstrong Avenue
Georgetown, ON, Canada L7G 5S4
Tel: (905) 877-4411

Distributed in the U.K. and Europe
by F&W Media International, LTD
Brunel House, Forde Close, Newton Abbot, TQ12 4PU, UK
Tel: (+44) 1626 323200, Fax: (+44) 1626 323319
Email: enquiries@fwmedia.com

Distributed in Australia by Capricorn Link
P.O. Box 704, S. Windsor NSW, 2756 Australia
Tel: (02) 4560-1600; Fax: (02) 4577 5288
Email: books@capricornlink.com.au

ISBN 13: 978-1-4403-4566-1

Edited by Kristy Conlin
Designed by Clare Finney
Production coordinated by Jennifer Bass

ideas. instruction. inspiration.

Receive FREE downloadable bonus materials when you sign up for our free newsletter at artistsnetwork.com/Newsletter_Thanks.

These and other fine North Light products are available at your favorite art & craft retailer, bookstore or online supplier. Visit our websites at artistsnetwork.com and artistsnetwork.tv.

Find the latest issues of **Cloth Paper Scissors** on newsstands or visit artistsnetwork.com.

Follow North Light Books for the latest news, free wallpapers, free demos and chances to win FREE BOOKS!

Get your art in print!

Visit artistsnetwork.com/splashwatercolor for up-to-date information on Splash and other North Light competitions.